THE KENNET & AVON CANAL

THROUGH TIME

Clive Hackford

AMBERLEY PUBLISHING

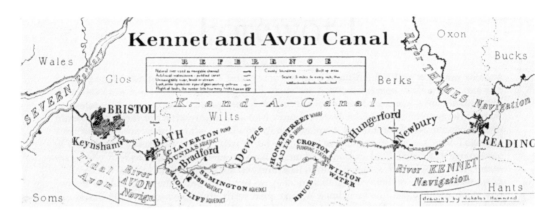

The illustrations in this book take the reader on a trip along the Kennet and Avon Canal (navigation) from Bristol Harbour to Reading on the River Thames as they seek to document a variety of changes both rural and urban. The most profound change has been from commercial waterway to cruiseway, supporting a wide range of leisure activities. Perhaps, through this pictorial journey, the reader may be inspired to visit some of the areas illustrated, learning about and enjoying this linear water park across southern England.

First published 2009

Amberley Publishing Plc
Cirencester Road, Chalford,
Stroud, Gloucestershire, GL6 8PE

www.amberley-books.com

Copyright © Clive Hackford, 2009

The right of Clive Hackford to be identified as the
Author of this work has been asserted in accordance
with the Copyrights, Designs and Patents Act 1988.

ISBN 978 1 84868 768 4

British Library Cataloguing in Publication Data.
A catalogue record for this book is available from
the British Library.

Typeset in 9.5pt on 11pt Celeste.
Typesetting by Amberley Publishing.
Printed in the UK.

Introduction

In the eighteenth century, the two most important ports in the country were London and Bristol. In 1723, the River Kennet was made navigable from the Thames at Reading to Newbury in Berkshire for barges up to 109 feet (33m) in length. By 1727, the Bristol Avon had been made navigable from Bristol to Bath. Then, in 1788, plans began to be formulated by potential investors to make an artificial cut or canal from Newbury to Bath. This would fulfil the long-held aspiration for an inland navigation to link London and Bristol avoiding storms around the Cornish coast and French harassment in the English Channel.

Following surveys and the necessary Act of Parliament, a start on construction was made in 1794 and the link was completed in December 1810, one year after completion of the floating harbour at Bristol. This new navigation became known as The Kennet and Avon Canal and allowed through passage of barges up to 70 feet (21m) long and 13 feet 10 inches (4.2m) in the beam, able to carry up to 100 tons. Trade was steady until the development of railways provided a faster service and railways became the new transport system of choice. In 1852, the Kennet and Avon Canal Co., with Government collusion, was taken over by the Great Western Railway Co., and at about this time many other canals were also taken over by railway companies.

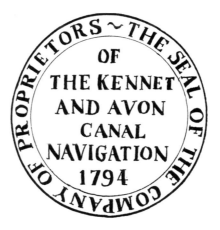

The Seal of the Kennet and Avon Canal Company

Some trade did continue, but from 1878 the canal made a loss for its new owners. The canal remained open, however, because its maintenance in a navigable state was part of the Act of Parliament that authorised the takeover, and this was further reinforced by the Regulation of Railways Act (section 17) of 1873. However, the railways were nationalised in 1948 and by this time only a very few stalwarts were using the canal. John Knill and John Gould became well known when they took legal action against the British Transport Commission, which had tried to close the canal in 1956. By this time the Waterway had degenerated into a serious state of disrepair, but action by John Gould in the High Court resulted in a stay of execution for the canal. As a result of action taken by enthusiasts, the canal was recovered and today is available for a wide range of leisure activities. The Kennet and Avon Canal Trust played a leading role in the restoration of the canal and today co-operates closely with British Waterways in ensuring that the canal not only remains navigable but that, in conjunction with riparian authorities, the towpath is maintained for walkers, fishermen and cyclists to enjoy all that the Waterway has to offer.

Further information on the work of The Kennet and Avon Canal Trust is given in an acknowledgement at the end of this book.

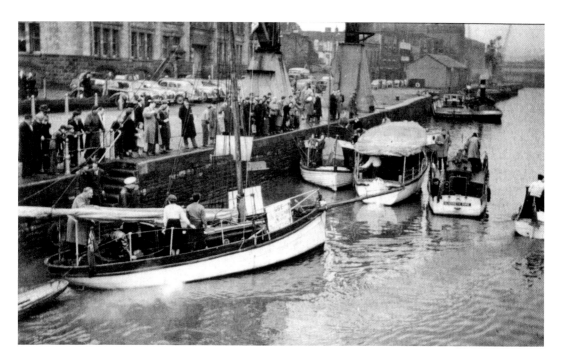

Narrow Quay Bristol

The scene at Narrow Quay, Bristol, catches the moment in 1956 when a 20,000-signature petition opposing the proposed closure of the canal by the British Transport Commission leaves for London. The cranes representing trade and industry are now gone, replaced by offices and leisure moorings. (Archive photograph by F. Blampied)

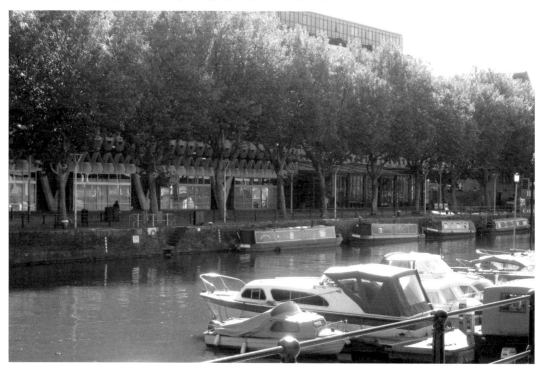

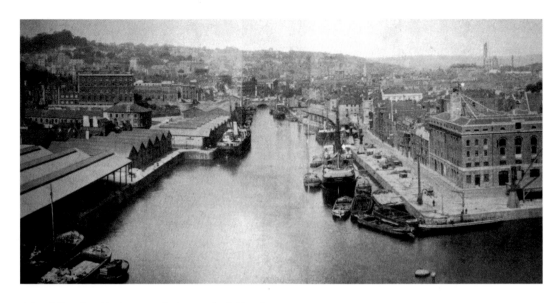

Bristol Floating Harbour — St Augustine's Reach

The view of St Augustine's Reach, *c.* 1900, was taken from the top of the Corporation Granary (destroyed 1941). The area has now been developed into shops, restaurants and offices but Bush Warehouse on Narrow Quay still provides the focal point in 2009, though from a different angle. Pleasure craft now replace commercial shipping, and the preserved cranes silhouetted against the sky, opposite the Reach, approximately marking the granary site, form part of the city's presentation of its maritime history. (Archive photograph from the collection of the Museum of Bristol)

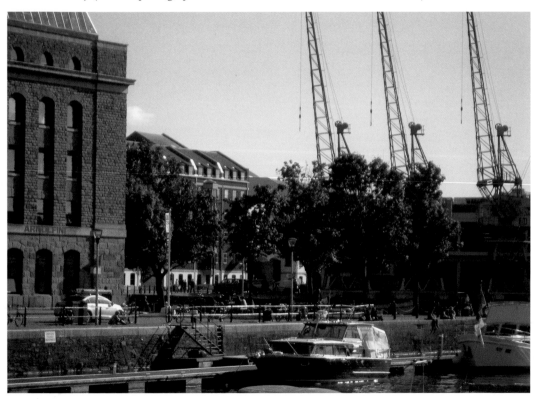

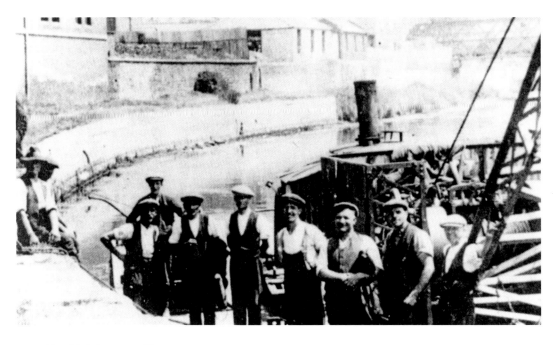

The Maintenance Men

During the 1930s, The Great Western Railway Co. undertook a big maintenance programme on the canal, and in 1933 this maintenance gang was photographed with a steam dredger near Midland Railway Bridge in Bath. It is interesting to compare their dress with that of contractors working in the Bath Valley in 2001. Waistcoats, bib and brace overalls and flat caps are out and high visibility clothing and hard hats are now considered important safety factors. Heavy equipment has also undergone considerable change. (Photograph of 2001 reproduced by permission of the Heritage Lottery Fund Partnership)

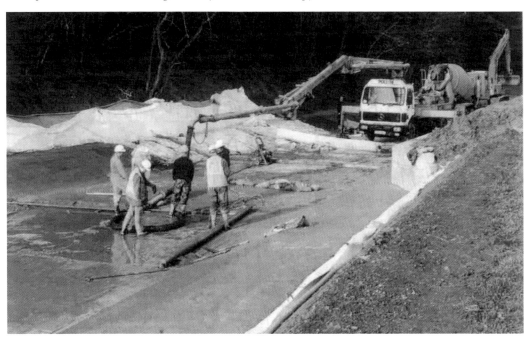

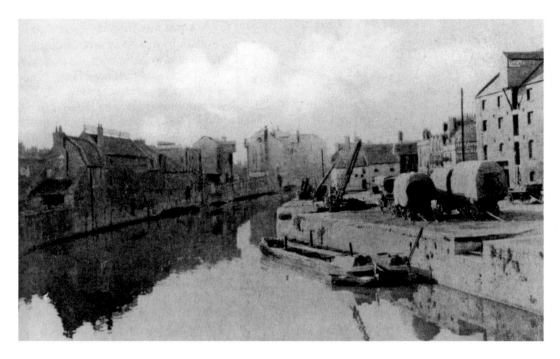

Broad Quay Bath

During the nineteenth century, Broad Quay in Bath was a very busy wharf. Waterborne trade between Bristol and Bath had been very brisk from 1727 onwards, but this scene *c.* 1890 seems rather quiet. This small area is typical of the way in which the city waterfront has developed, facilitating greater public access, though the mills on the left remain. It was here that boats were once busy unloading sacks of grain. (Archive photograph from the collection of Michael E. Ware)

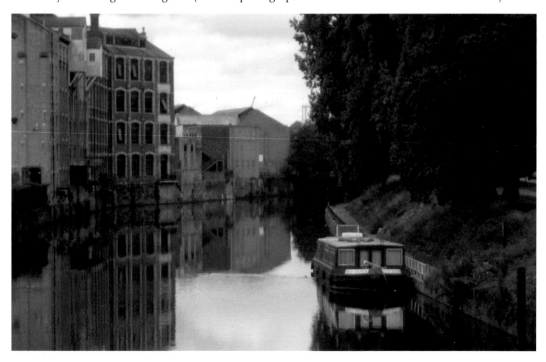

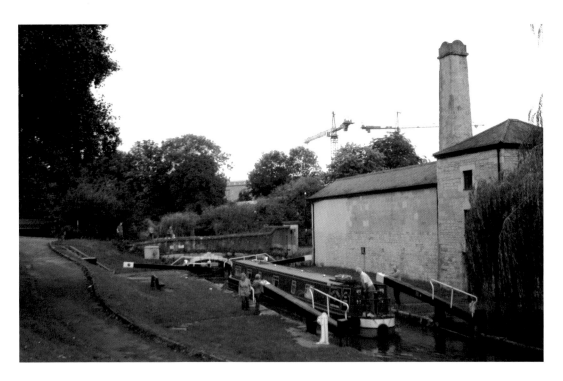

Bath lock No. 7 — Thimble Mill

Lock 7 marks the junction of the Newbury to Bath section of the Waterway with the River Avon, downstream from Pultney Weir. The river flows right to left just beyond the stone bridge, and the station in *c.* 1960 could be seen in the background. The building on the right was built in 1833 to house a steam engine, which pumped water to a point above lock 11 on the Bath flight at Widcombe. The pumps were removed in 1855 but the building is now restored and serving business interests.

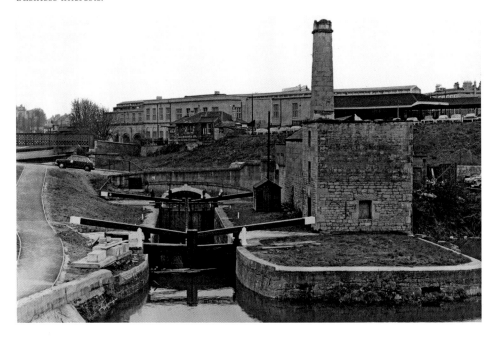

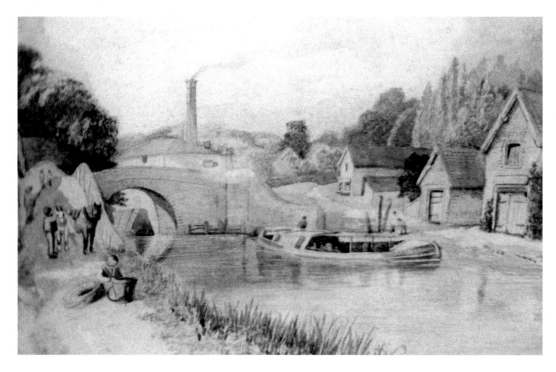

Bath flight of locks

Pultney Road Bridge fixes the position of this nineteenth-century painting of part of the Bath, or Widcombe, flight of locks. Smoke coming from the stack of the lower pump house beside lock 7 suggests a date of shortly after 1833. The scene today is markedly different. The old storage facilities have gone and modern road transport has demanded a new bridge.

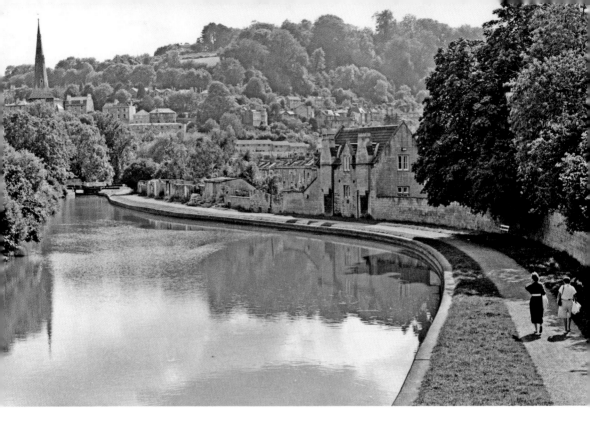

Lock No. 10, Bath Flight of Locks.
Looking south-west down the Bath flight of locks at Widcombe towards lock no. 10, Wash House Lock. Before the iron footbridge was built below this lock children would cross the lock along the slippery top of the gates. The lovely view is unmarred today and the area retains its serenity.

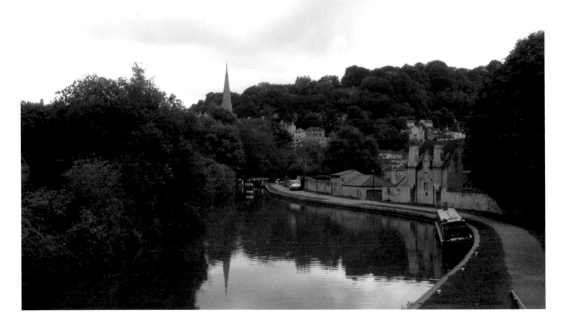

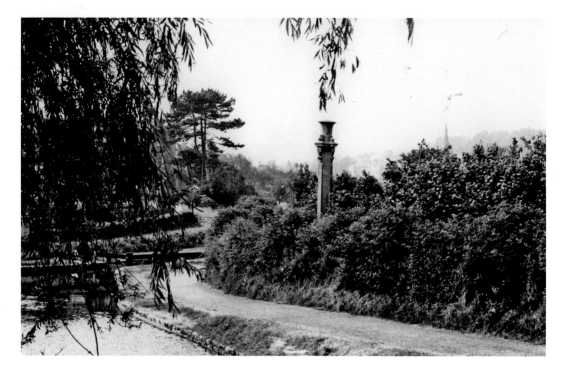

Bath Flight of Locks — Pumping Station

Lock 11 can just be seen through the branches of the overhanging tree. The solitary chimney is all that remains of the upper pumping station which formed the second stage of a two stage system for pumping water from the bottom of the lock flight to above the top lock (no. 13). This completed the lift for an early form of back pumping 150 years ago. A small amount of residential development has occurred in the fifty years between the two photographs.

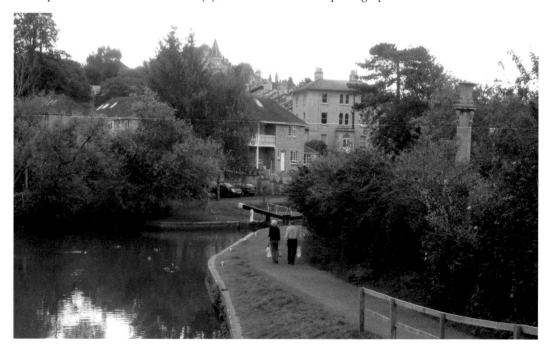

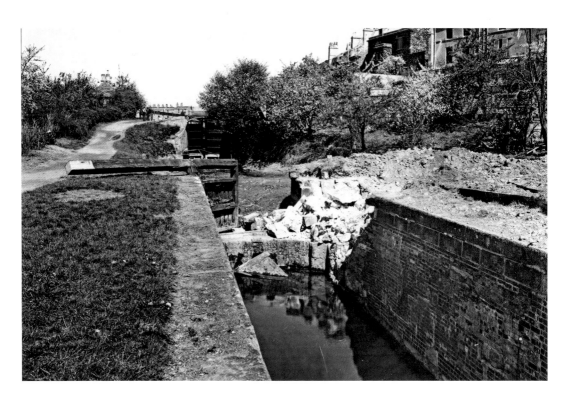

Bath Flight Lock 12

Standing beside the chamber of lock no. 12, the damage seen to the top gates was the result of action by one of Herr Hitler's pilots during the Second World War. The pilot was probably returning from a bombing raid on Bristol and had a spare munition, which he released, having seen a glint of water from the canal. All has now been repaired and the splendour of this flight of locks is restored.

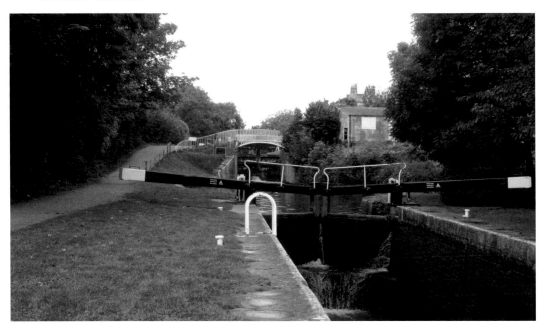

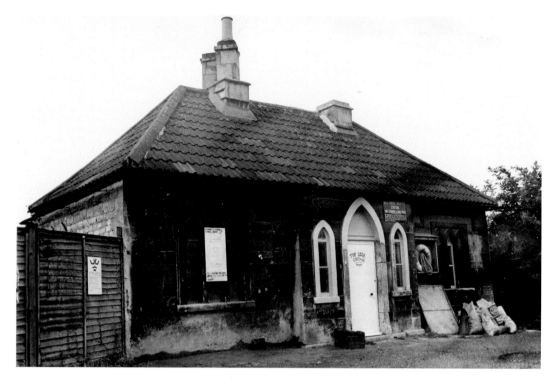

Bath Flight Lock Cottage

The use of Bath stone at the western end of the canal provides a distinctive form of architecture. This lock cottage, photographed in 1950, is at Bath top lock (13) and in the nineteenth/early twentieth century would have been the home of the lock keeper for the flight. The census of 1891 tells us that David Mizen was the lock keeper here and his father spent the later years of his life here also. The cottage remains unaltered but in greener surroundings.

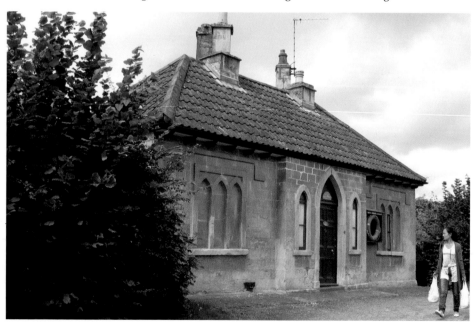

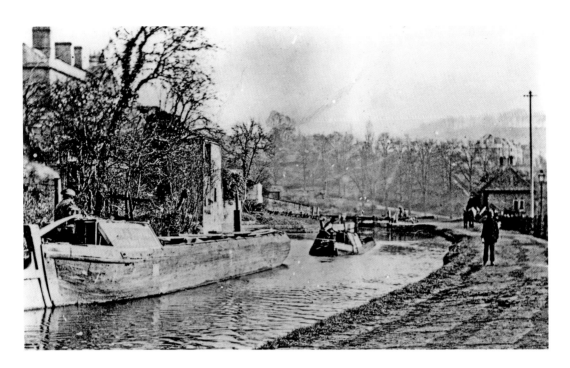

Bath Top Lock

A pair of narrow boats owned by the Gerrish family approaches Bath top lock *c.* 1890. The lead boat is laden while the towed craft is clearly empty. Because the top gates of the lock are not yet open the horse has been halted but not uncoupled. A coal wharf and stable block are on the offside near the lock. No horses now pass this way, though the flight in summer can be busy with boats.

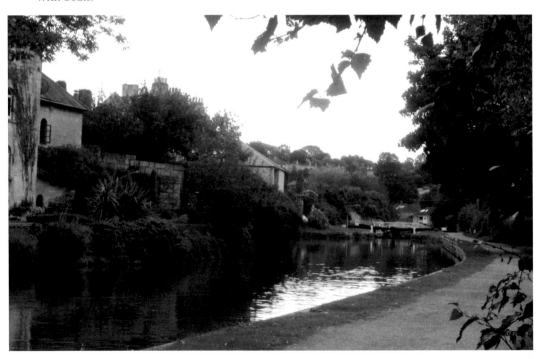

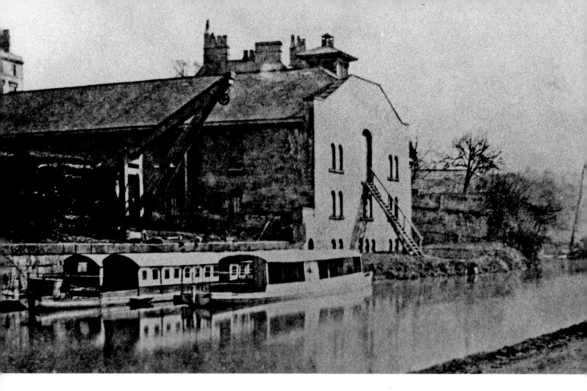

Bath, Baird's Maltings

The building known as Baird's Maltings was situated just above Bath top lock. Pictured *c.* 1860, the wooden crane on the wharf stands idle overhanging a trio of Swift Boats, which by 1855 were redundant. They had provided a fast service to Bradford on Avon with first- and second-class accommodation hauled at the canter by a team of horses. The maltings building survives still in its original form but boats no longer need to deliver sacks of barley.

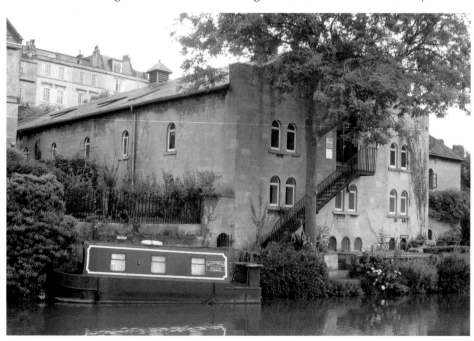

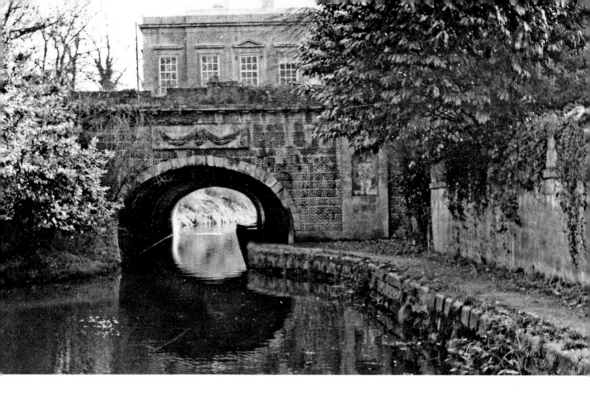

Cleveland House — Bath

Cleveland House sits atop a short tunnel forming the Sidney Road bridge through which, travelling north, one enters the splendour of Sidney Gardens. This view looks south from just inside the gardens, which are traversed by the canal. Once the rented headquarters of the Canal Company, it remains in commercial use. Originally built by the Duke of Cleveland *c*. 1800, its history was researched by Michael Davis whose work was reproduced in 2001 by the Kennet and Avon Canal Trust in its magazine, *The Butty*.

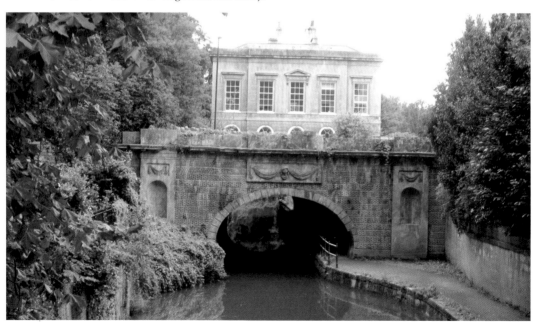

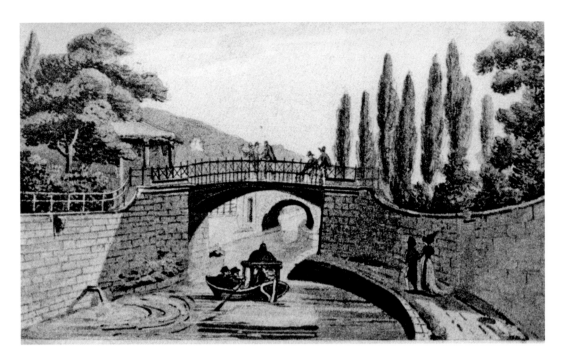

Sidney Gardens — Bath

Heading north from Cleveland House one enters the hexagonal layout of Sidney Gardens, originally part of the Bathwick Estate, with its ornate iron footbridges. The gardens retain their tranquillity and can be entered from the grounds of the Holbourne Museum at the end of Great Pultney Street or by following the towpath up the Bath flight.

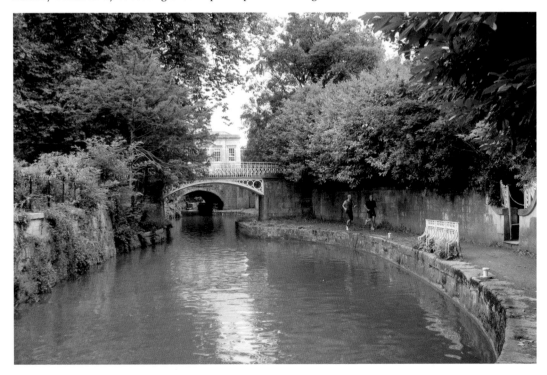

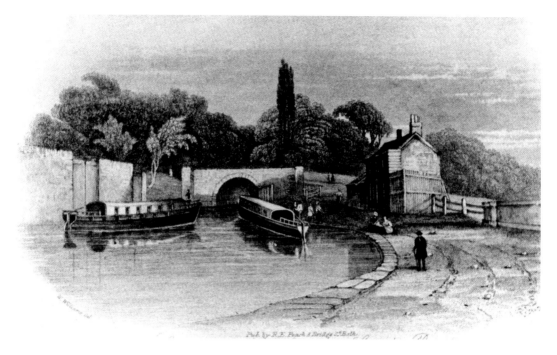

Darlington Wharf — Bath

After leaving Sidney Gardens through the tunnel under Beckford Road, the old site of Darlington Wharf lies opposite the towpath. This sketch from *c.* 1850 shows the Swift, or Scotch, Boats using the towpath outside the lengthsman's cottage as a transit point for their foot-passenger service. Nothing remains of the wharf today, but one can still stand on the towpath beside the cottage and imagine the activity 160 years ago at this point.

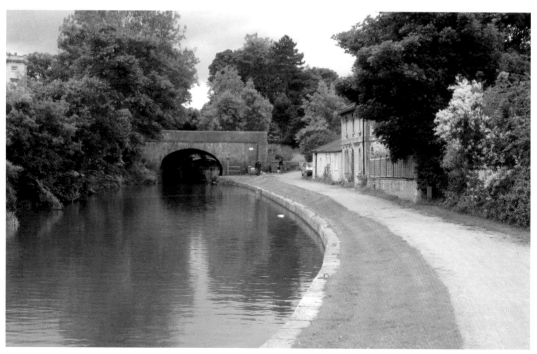

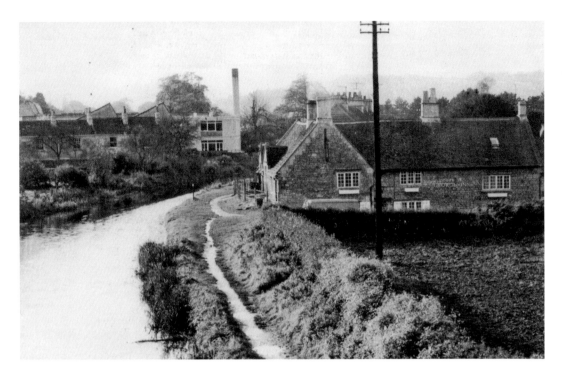

Bathampton

Further to the east the canal runs through Bathampton. In this photograph from the 1950s the canal weaves a careful route round the George Inn, with Harbutt's plasticine factory having been built on the opposite bank on the site of Harbutt's Mill. The plasticine factory has gone but the George Inn continues to slake many a thirst.

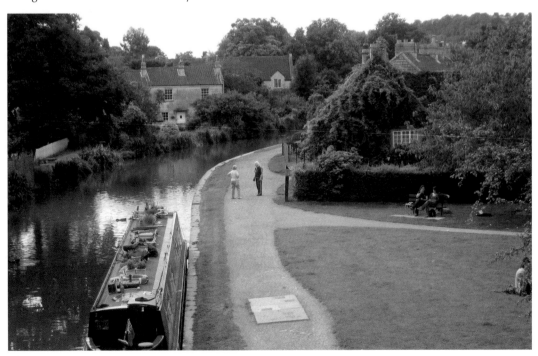

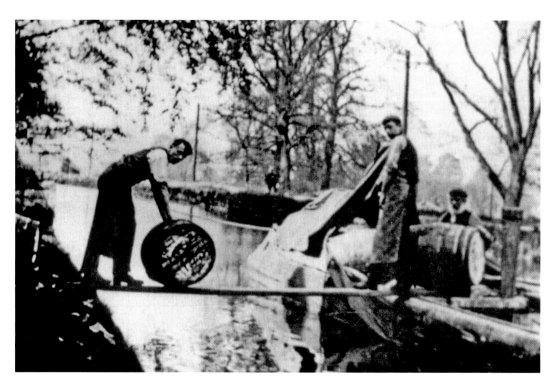

Harbutts Plasticine Factory — Bathampton
Barrels of plasticine are being rolled out from the Harbutt's factory *c.* 1920 for delivery by canal. The factory received its raw materials and coke by canal as well as using the canal for transporting the finished product. With the factory gone, mostly pleasure boats now pass this way.

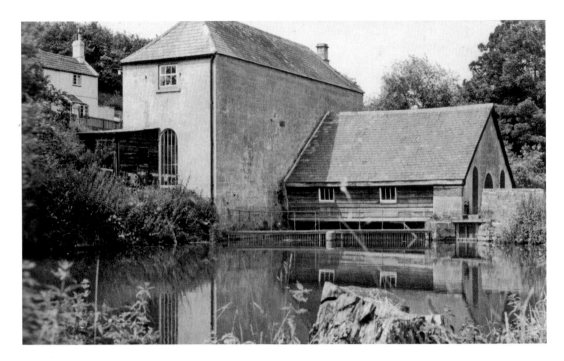

Claverton

The Claverton pumping station was built in 1813 by John Rennie. The huge water wheel, which is driven by the River Avon, pumps water from the river to the canal. The building has not changed over the past fifty years and, inside, the machinery has been restored by the Canal Trust. It is now open for public viewing, with regular working days of the water wheel each month. The cottage in the background was once the home of the pump man and his family.

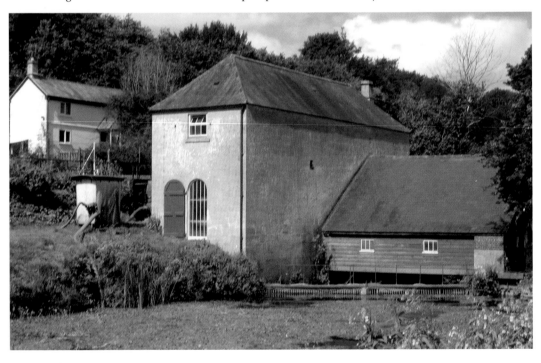

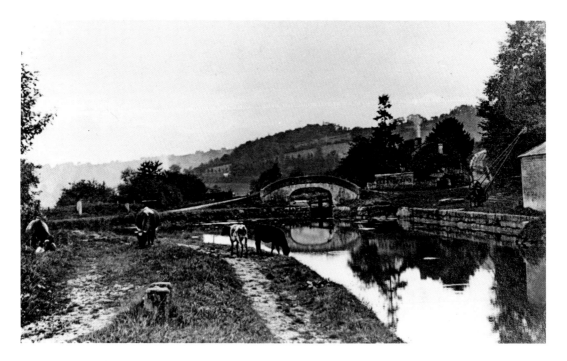

Brassknocker Basin

In 1900, the towpath crossed the entrance to the Somerset Coal Canal by a stone bridge as the Kennet and Avon Canal turned sharp left to cross the Dundas Aqueduct. The scene, which includes Brassknocker Wharf, remains unchanged today except that the stone bridge has been replaced by a lift bridge. The Somerset Coal Canal remains derelict except for the first half mile, which is used for moorings and access to a visitor centre. (Archive photograph from the collection of D. L. McDougal)

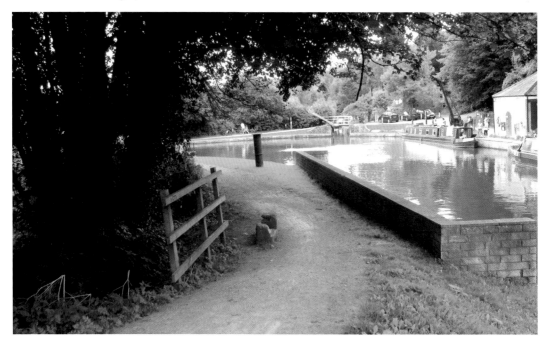

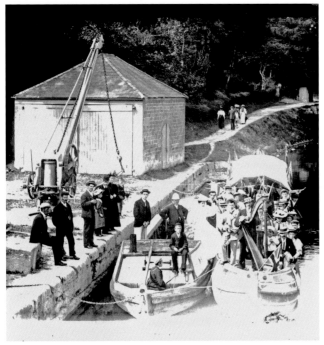

Brassknocker Wharf

A canal excursion in 1897 makes ready to depart Brassknocker Wharf. Evidently a distinguished occasion, as indicated by the Union Jacks, the string accompaniment, the lady in the elegant white dress and the helmsman in a pith helmet. This was either a celebration of a national event or a wedding party. In 2009, a boatload of young ladies also enjoy a summer excursion. The ¼ ton stone blocks, which have survived on the wharf for more than 100 years, were once used in the gauging of boats.

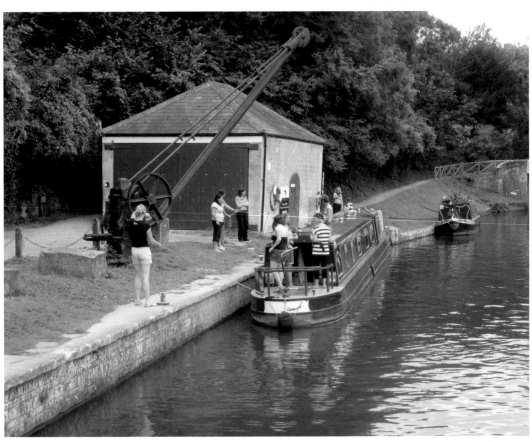

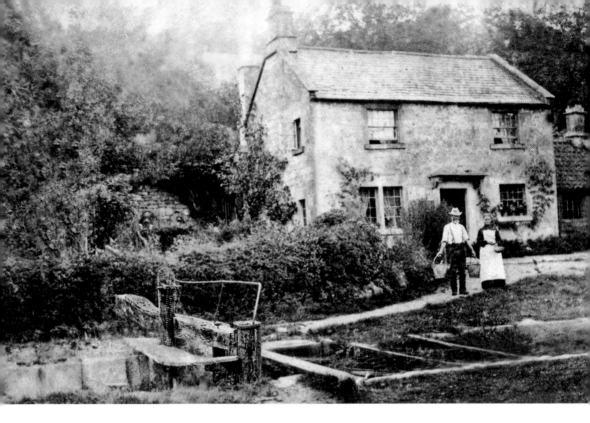

Somerset Coal Canal

Pictured *c.* 1900, the lock keeper and his wife stand outside the front of their cottage at the entrance lock to the Somerset Coal Canal at Brassknocker Basin. Today, there is no lock keeper though the lock remains open for through passage of boats, within the bounds of the now private garden. The 2009 photograph was taken at a different angle, and the original lock cottage can be identified by its chimney.

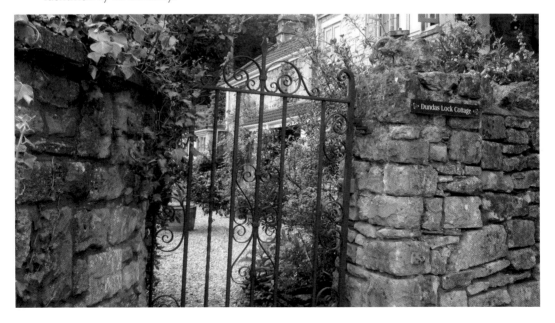

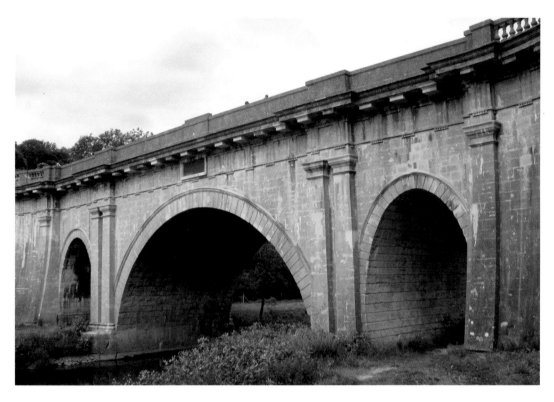

Dundas Aqueduct

Designed by John Rennie in the Doric style, the Dundas Aqueduct was so named after the first chairman of the Canal Company. It is one of two aqueducts carrying the canal across the Bath valley in order to maintain the same contour line. Dundas Aqueduct has recently undergone extensive maintenance work to restore its original splendour.

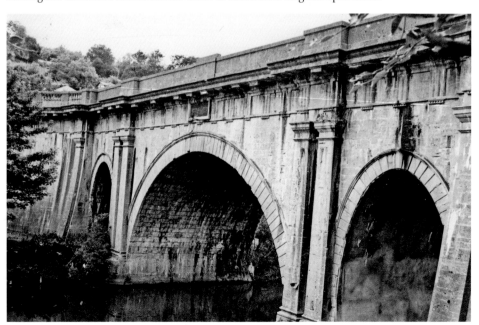

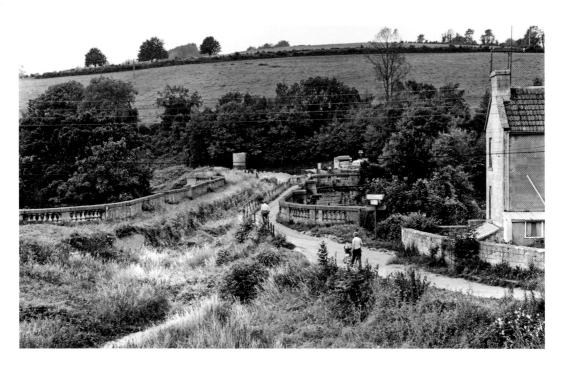

Avoncliffe

In 1948, when the Railway Executive took over railways and canals, the Kennet and Avon Canal was just navigable with difficulty. However, lack of maintenance resulted in this sorry scene at Avoncliffe Aqueduct. Bath stone from Westwood quarry was once taken to a wharf at the southern end of the aqueduct and subsequent to the building of the railway the tramway was extended along the aqueduct to railway sidings. Restoration has dramatically transformed a scene of sorry neglect.

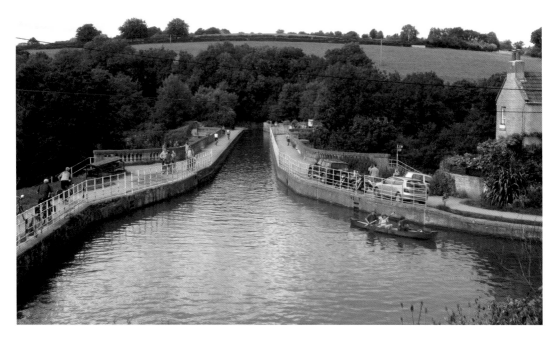

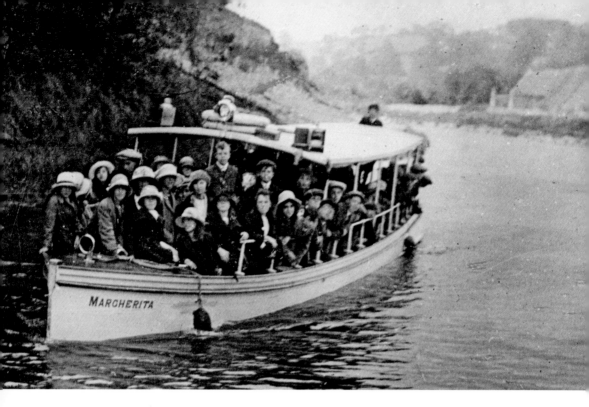

Bradford on Avon — Tithe Barn

The launch *Margherita* approaches Bradford on Avon passing the just visible tithe barn on the right *c.* 1920. It is packed with young people on a pleasure outing. Today, being situated alongside Barton Farm Country Park, it is a popular mooring spot for pleasure craft. The tithe barn is now restored but obliterated by trees from this point.

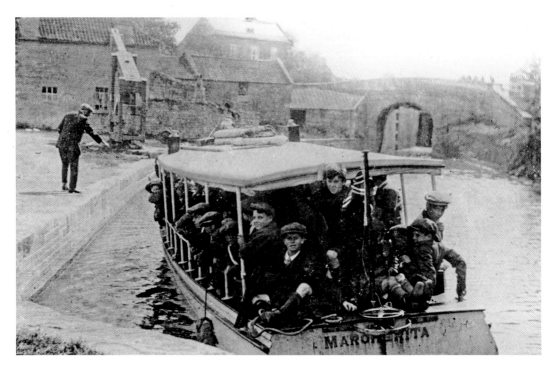

Bradford on Avon — Lower Wharf

The *Margherita* approaches Bradford on Avon Lower Wharf, adjacent to the road bridge. Through the bridge hole can just be seen the lower gates of the town's lock. The crane has long since disappeared and trade of a different sort has taken over. Now food and drink is available at a number of outlets, making this an attractive and popular spot.

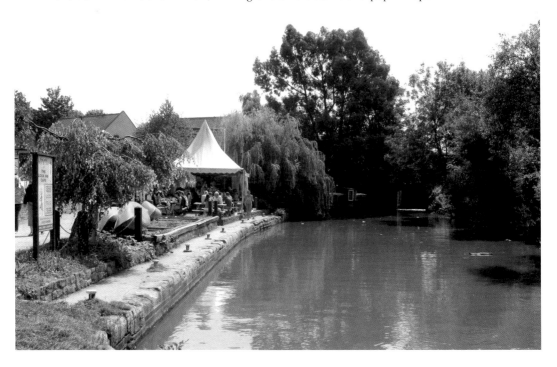

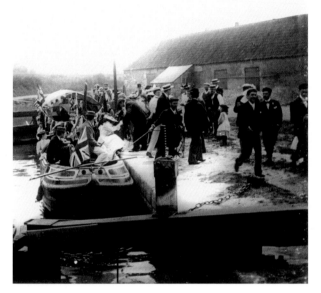

Bradford on Avon — Town Wharf
The 1897 excursion party, which boarded at Brassknocker Wharf (page 24), is now disembarking at Upper Wharf within the lock, the boat having first been turned round in the winding area above the lock. A popular spot then as it is now. On the left, the lock cottage is now a Canal Trust café, shop and information centre. From here the Canal Trust also runs the fifty-one-seat trip boat *Barbara McLellan.*

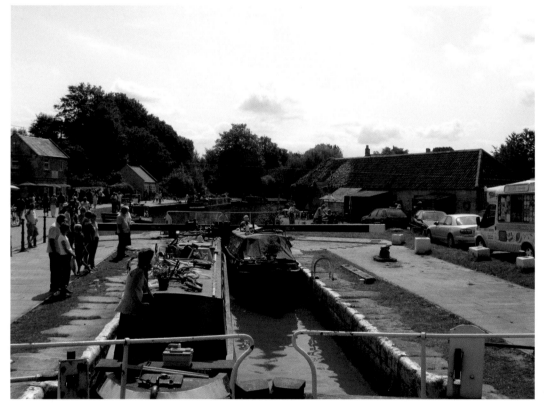

Bradford on Avon — Barton Farm Country Park

The original photograph of 1897 was taken from the canal towpath looking across to the River Avon and what is today Barton Farm Country Park. Tree growth precluded the later photograph being taken from the towpath but the view remains much the same. It is a lovely walk alongside the River Avon to Avoncliffe and then to return via the canal towpath.

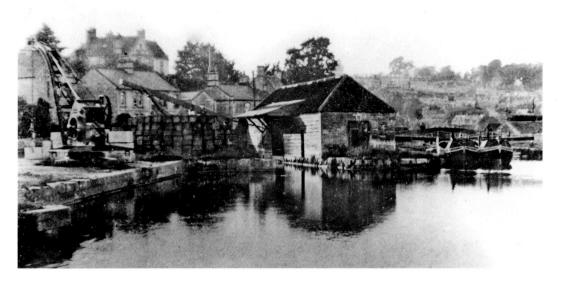

Bradford on Avon — Upper Wharf

Two boats stand guard at the upper entrance to Bradford on Avon lock, while two cranes on the wharf stand idle with no one in sight. This general air of dereliction was captured *c.* 1920 when trade was already in decline. Although the cranes have gone it is a brighter scene now with the old warehouse having become a café.

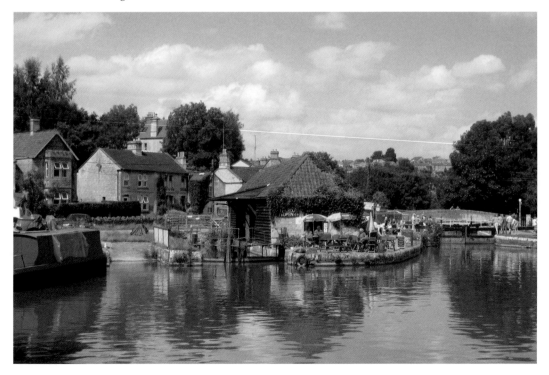

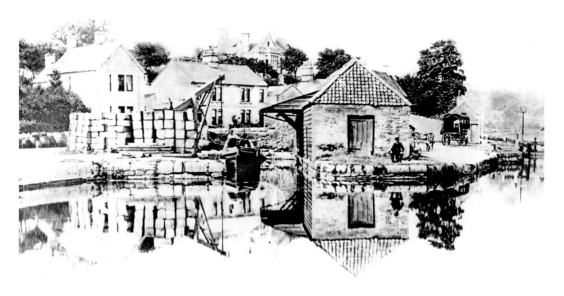

Bradford on Avon — Upper Wharf

The earlier scene of 1890 catches a boat in the gauging dock having weights lowered into it so that toll collectors could determine the weight of cargo being carried from a record of loaded weight v. freeboard. The wooden crane is clearly dedicated to this task. The gentleman sat on the mooring bollard is possibly connected with the wagons waiting round the corner. He is replaced today by café tables; the wagons, by an ice cream van; and the gauging dock, by a dry dock.

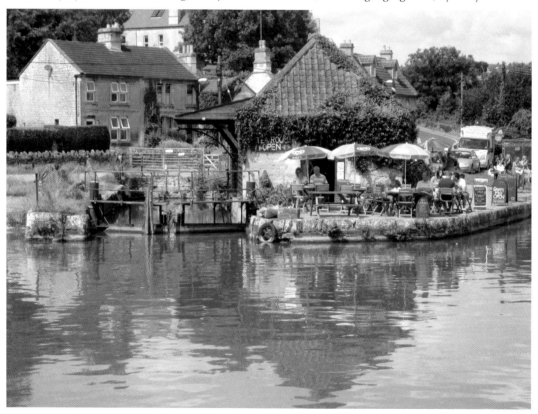

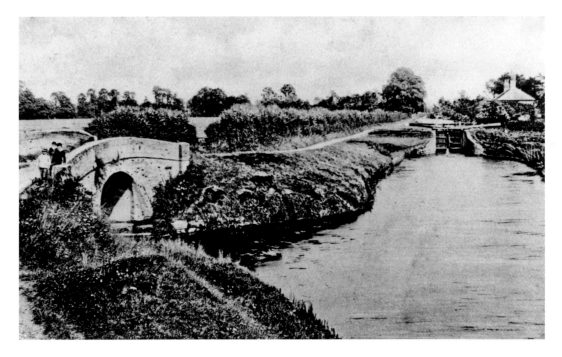

Semington

From Semington road bridge, with the lower of two locks in the distance, the Wilts and Berks Canal joins the Kennet and Avon on the left. Between 1810 and 1876, this was a busy junction but the scene of *c.* 1920 postdates closure of the Wilts and Berks. Although the Kennet and Avon remains busy with pleasure craft, the entrance to the Wilts and Berks is bricked up and the canal filled in. Restoration of the Wilts and Berks is in progress

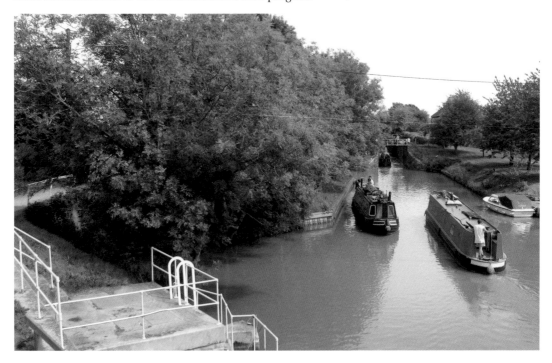

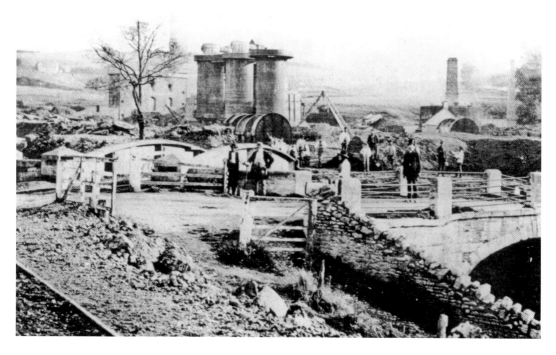

Seend

An ironworks once stood on the south side of the Canal at Seend, with peak production occurring between 1873 and 1888. The early photograph shows three blast furnaces but only the road bridge still exists. A branch of the works railway can be seen to divert to Seend Wharf. In 2009, the photograph was taken from where the two men are pictured standing on the road bridge. The railway embankment to the main line can still be traced today. (Archive photograph from the collection of Wiltshire County Council)

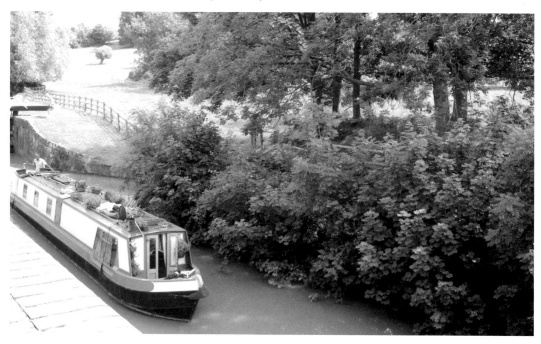

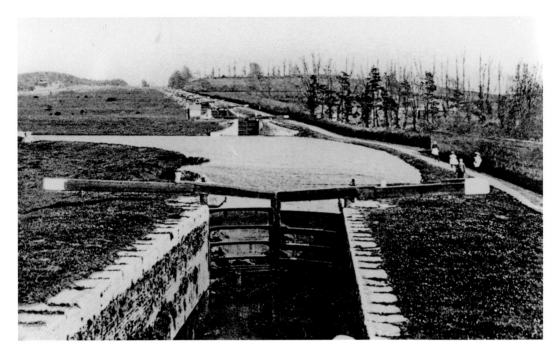

Devizes — Caen Hill Locks

This early view of Caen Hill's sixteen locks dates from 1910. Large side-ponds on the left (north side) provide a reservoir of water for each of the locks. The white painted rails of the footbridges, one at the bottom end of each lock, make the ascent of the flight appear even more imposing today. These 16 locks are part of the Devizes flight of locks, 29 in all, lifting the canal 237 feet (73m) in 2 ¼ miles.

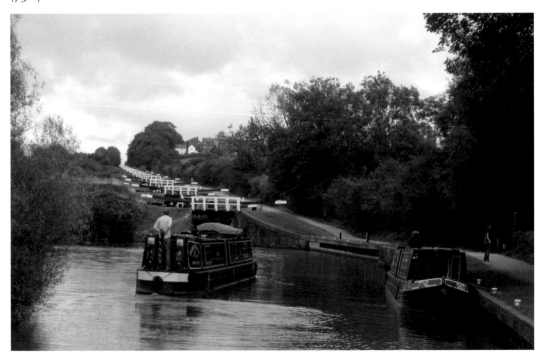

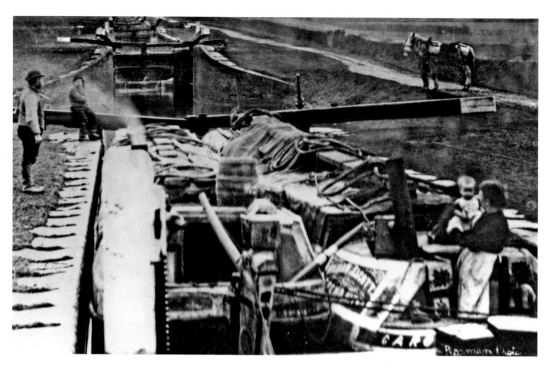

Devizes — Caen Hill Locks

The horse waits patiently for the lock to fill as the boats *Caroline* and *Argo* start the ascent of Caen Hill *c.* 1870. Men then worked the locks and the women, the boats, but the observer today will notice a marked reversal of these roles.

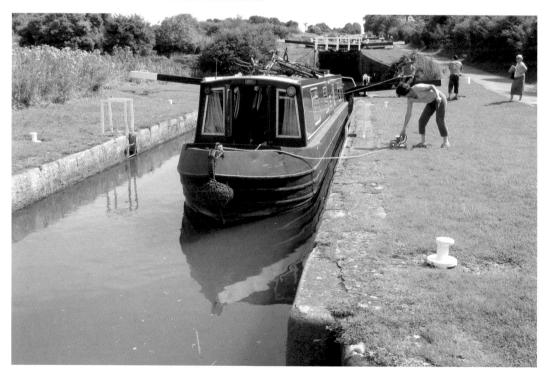

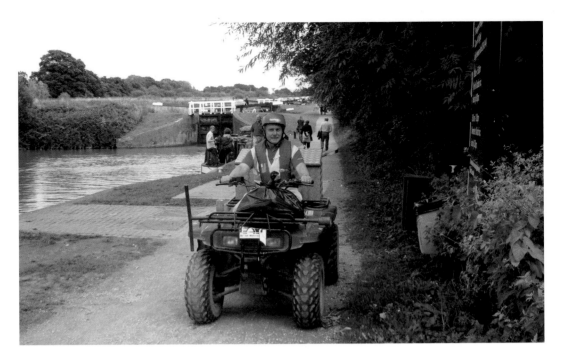

Devizes — Lengthsman Caen Hill Locks

Marsh Lane Basin provides the backdrop for this view of the lengthsman's hut, which once stood beside Caen Hill bottom lock. The lengthsman would have had responsibility for a section of canal — in this case probably the twenty-nine locks from Foxhanger to Devizes. Rob the lengthsman, pictured in 2009 beside Marsh Lane Basin, is much more mobile with a quad bike, life jacket and crash helmet.

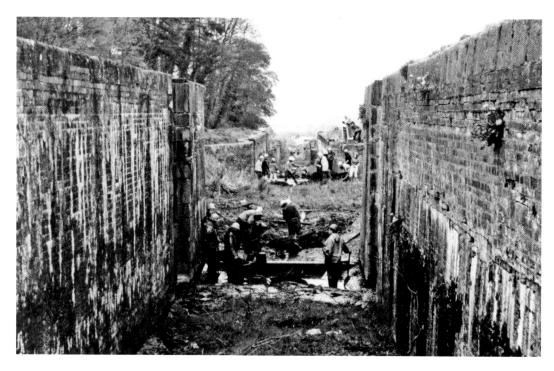

Devizes — Caen Hill Locks

Debris, mud, bushes and trees were largely cleared from Caen Hill by young volunteers from the Trusts Junior Division. By 1972, the task was clearly well advanced and the transformation now to leisure use is very evident.

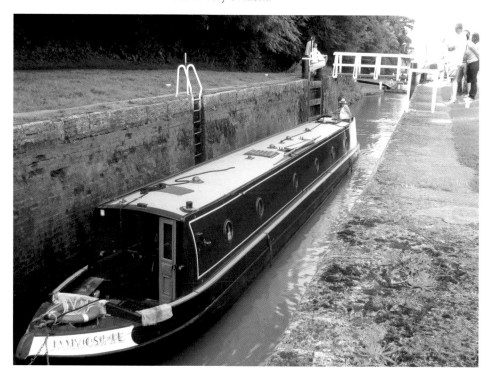

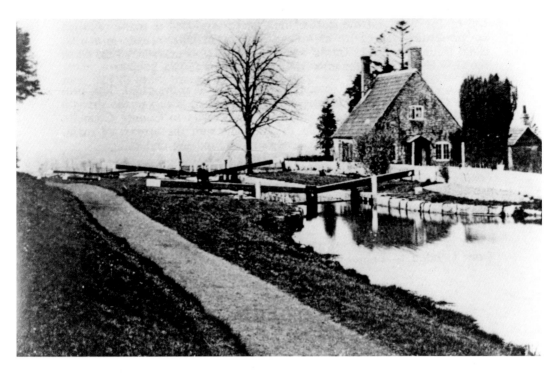

Devizes — Lock Cottage, Caen Hill
The scene surrounding the lock cottage at lock 44 at the top of the Caen Hill flight has changed little over the past 100 years, except that it is now surrounded by trees. The cottage now offers walkers and visitors to the flight light refreshment in pleasant surroundings. The spectacular views remain as ever.

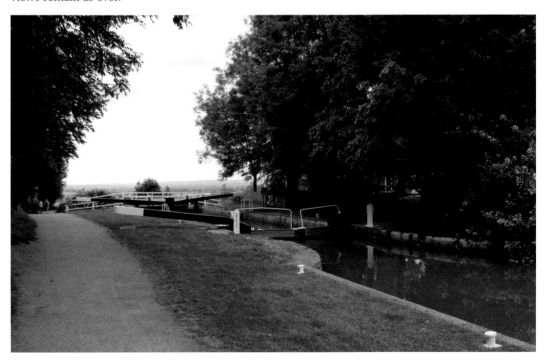

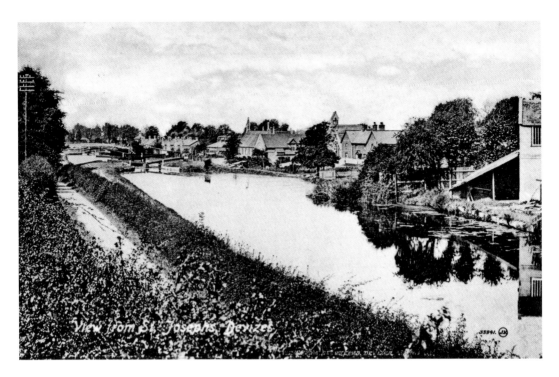

Devizes — Lock 49

After Caen Hill, on the final stretch of the canal into Devizes from the west, there are 6 locks (45 to 50 inc.). Looking back at lock 49 from St Joseph's church, the pound below is just visible and was once the site of Devizes town swimming pool. Above the lock and opposite the towpath is Sussex Wharf, now the site of a Quaker meeting house.

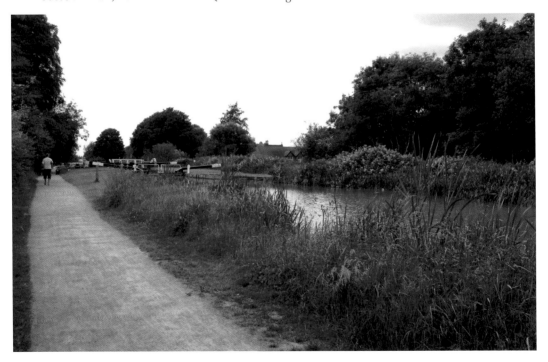

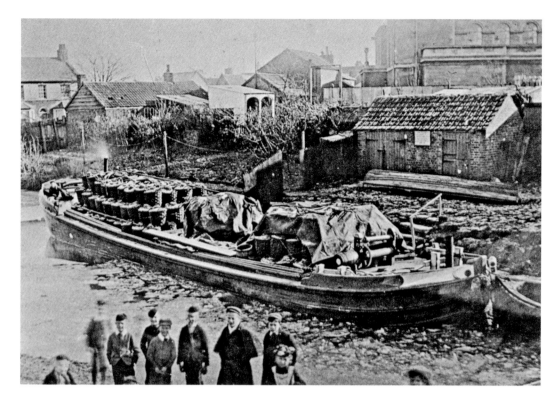

Devizes — Lower Wharf

The Kennet barge *Unity* lies berthed at Lower Wharf Devizes just 200 metres west of today's wharf car park. No sign of the horses and the small stable block appears to be empty in this wintry scene of *c.* 1910. The cargo of empty acid carboys is en route from Honeystreet to Avonmouth. Today, modern housing has appeared, though the stable survives — just.

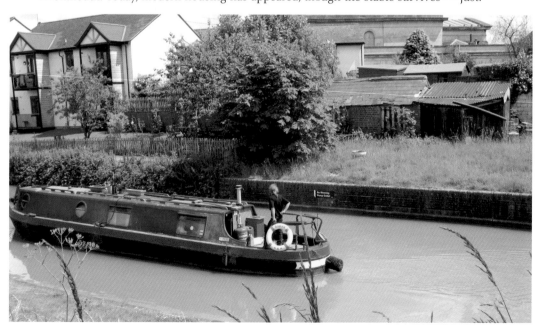

Devizes — Town Wharf

William Dickenson's wide boat *Croxley* loads grain at Devizes Wharf *c*. 1900. The warehouse is now the town's wharf theatre. The cottages are gone, replaced in today's scene by motor homes. The car has replaced the horse and leisure craft, the working boat. The doors of the annex to the warehouse bearing Dickenson's business description are now safely housed in the Canal Trust's museum on the wharf.

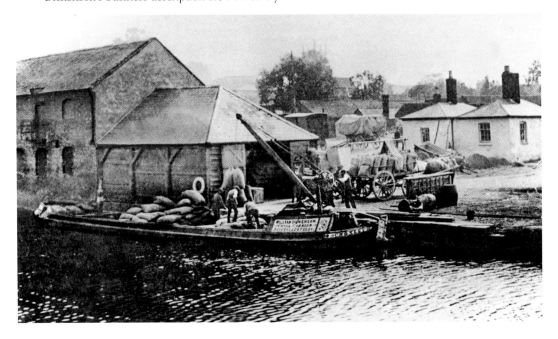

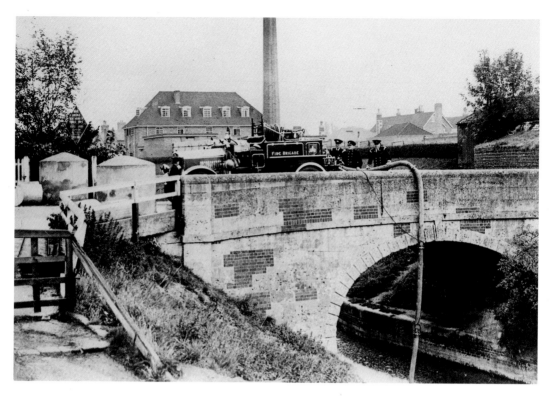

Devizes — Cemetery Road Bridge

Cemetery Road bridge, Devizes, alongside the wharf provides the platform for a Second World War fire pump test. The hooded headlamps, the 'tin' helmet and the respirator were all common wartime items. The concrete, anti tank 'dragon's teeth' were strategically positioned, presumably to prevent Herr Hitler's tanks reaching the cemetery. The hospital chimney remains a prominent landmark today despite the efforts of the trees to provide a verdant screen.

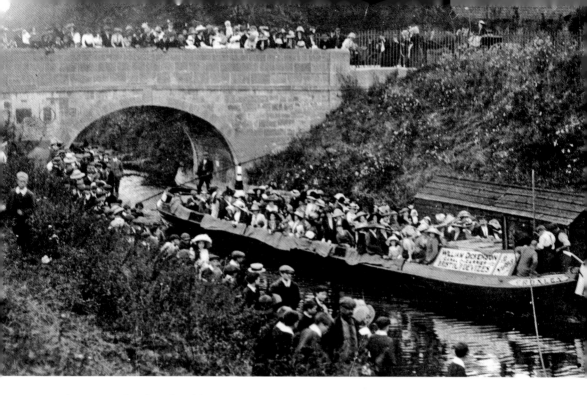

Devizes — Quakers' Walk Bridge
Quaker's Walk Bridge, Devizes is the backdrop for two forms of the same leisure activity approximately 100 years apart. *C*. 1900, one of William Dickenson's boats has been scrubbed and lined with canvas to provide a clean environment for what is probably a church outing. Travelling in the opposite direction, but in the same place today, is a more comfortable development in canal leisure transport.

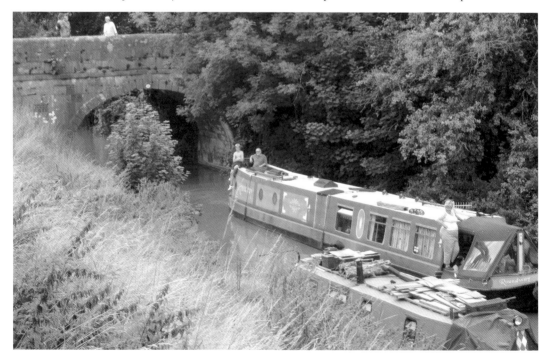

Horton Bridge

Travelling eastward from Devizes, the canal enters the Vale of Pewsey. After 2½ miles Horton Bridge stands at the beginning of a northerly loop and beside it stands the Bridge Inn. A petition against closure of the canal was transported in 1956 by boat and canoe from Bristol (page 5) to London. This early photograph of the canoe stage was taken at Horton Bridge with a well-dressed canoeist pictured attired in sports jacket and trilby hat.

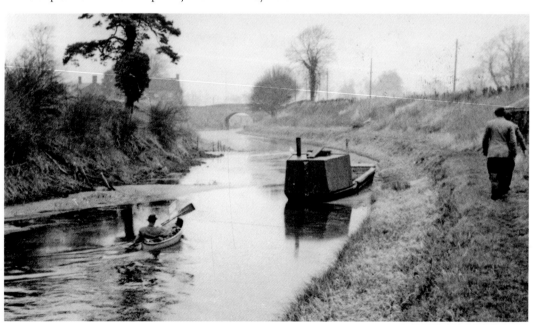

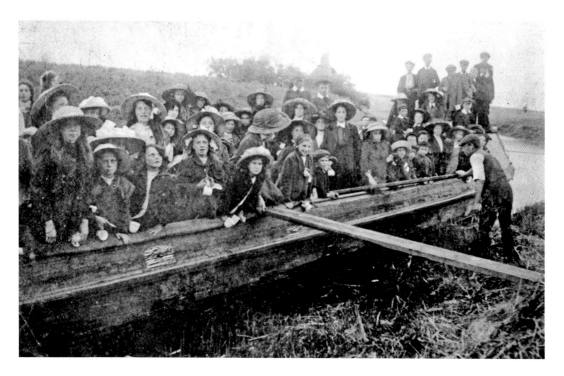

Horton Chain Bridge

At the north-eastern end of Horton village is Townsend Bridge (Horton Chain Bridge). Just beyond the bridge, a boat load of young people in about 1910 sets off on what is probably a Sunday school trip, with mugs slung round their necks. Today, a hire boat passes the same spot, with the gable end of the old lengthsman's cottage in the background. The cottage became the home of the late General Stockwell, an early campaigning chairman of the Kennet and Avon Canal Trust.

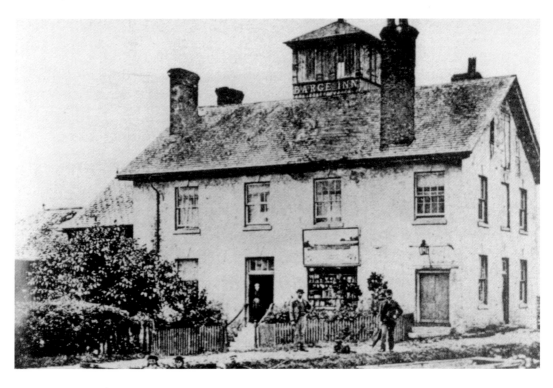

Honeystreet — The Barge Inn

Honeystreet lies midway between Devizes and Wootton rivers on a long, lock free 15-mile pound. Pictured in about 1890 is the Barge Inn, at this time also a general store, brewery, bake house and slaughter house. It is now a popular spot for visitors who sample the food and drink. The towpath is in the immediate foreground and the inn appears to have lost its lantern roof.

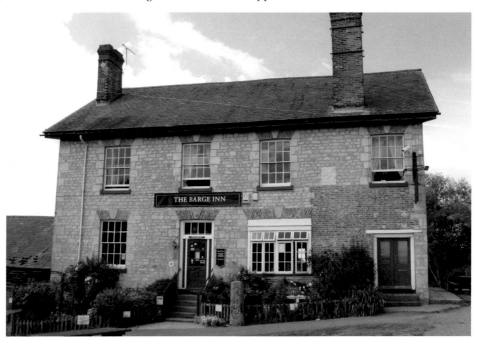

Honeystreet — Mini Fort

During the Second World War, the Kennet and Avon Canal formed part of a defensive line across southern England, but Hitler's narrow boats never arrived. Many mini forts or pill boxes were built along this line and housed machine gun or anti tank weaponry. A few of these forts were disguised as something quite innocuous and here we see such a barrel-roofed construction almost opposite the Barge Inn. No traces of this building remain today.

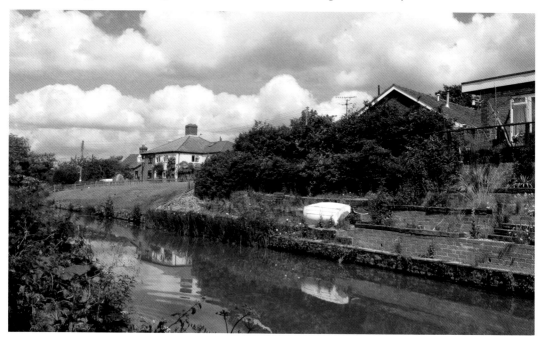

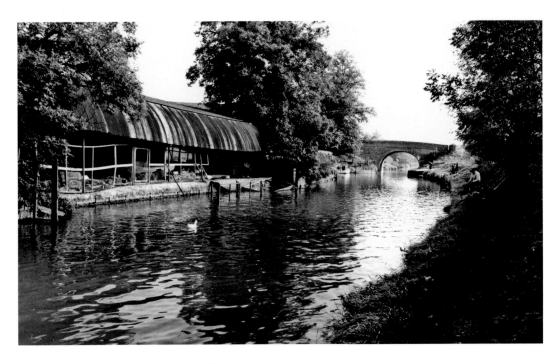

Honeystreet — Boat Building Shed

The business of Messrs Robbins Lane and Pinnigar was established in 1812. The business traded in timber and manufactured all manner of agricultural needs, including fertiliser. It successfully entered into boat building, producing barges, narrow boats and trows. The business closed in 1933, and the early photograph shows the post-1950 remains of the boat-building shed. Private housing and warehousing have now taken over the site.

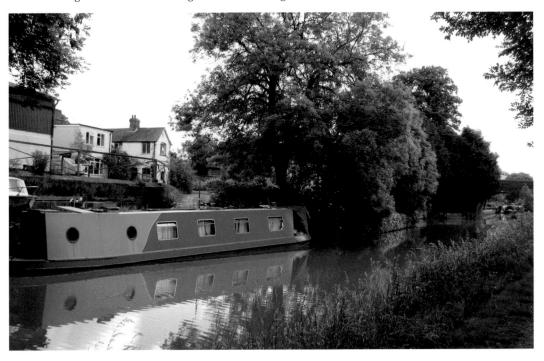

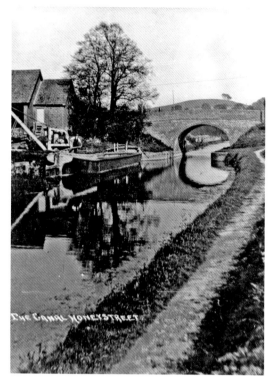

Honeystreet — Barge Unity

A Kennet barge, the *Unity*, lies at the wharf of
Robbins Lane and Pinnigar (RLP) in the 1920s.
Facing east, the barge, 69 feet long and 13 feet
10 inches in the beam, is berthed between
the boat-building shed and Honeystreet road
bridge. RLP owned a small fleet of boats and
traded extensively in imported softwood and in
hardwood from the Savernake Forest. The wharf
area has now succumbed to a green advance of
trees and bushes hiding some light industry.

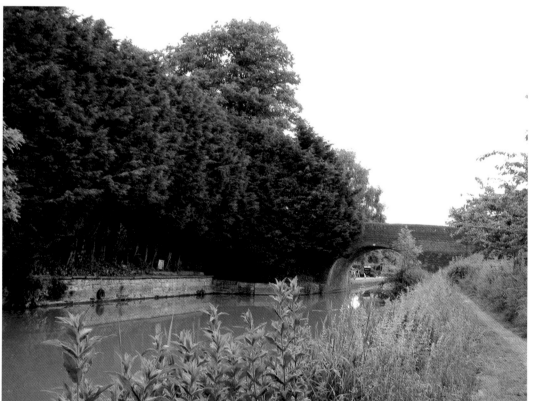

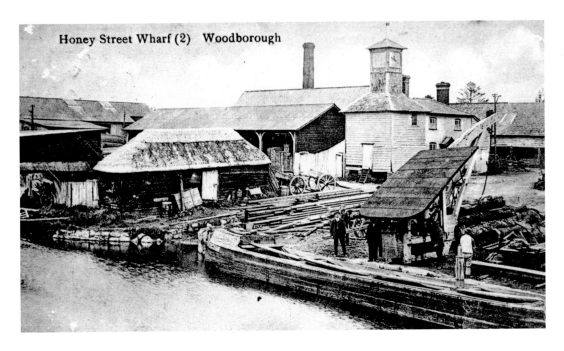

Honey Street Wharf (2) Woodborough

Honeystreet Wharf

Looking from Honeystreet road bridge and above the towpath gives a good perspective of Honeystreet Wharf. *C.* 1910, the heavy roundwood timber is stacked beside what appears to be a sawpit. Of the six men in this photograph two have their trousers tied below the knee as a safeguard against rats. The clock is now in Crofton pumphouse, though the chimney remains. This once carried the furnace gas from the production of steam used in the bending of boat timbers.

Inset: Honeystreet Wharf clock

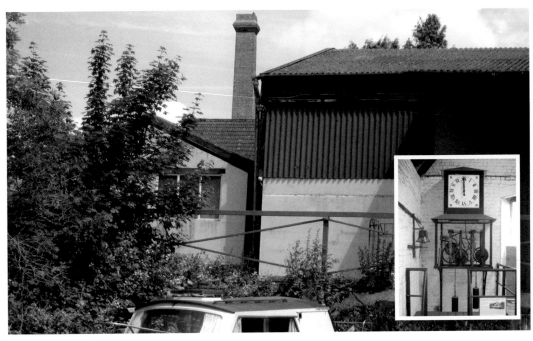

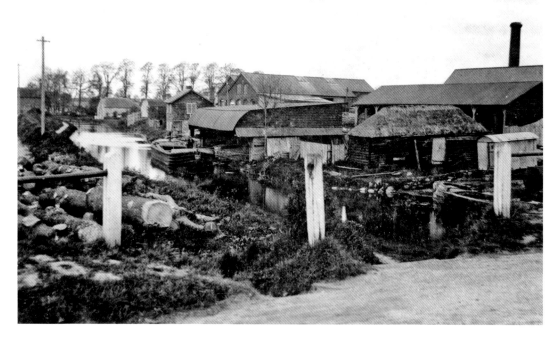

Honeystreet Sawmill

Robbins Lane and Pinnigar once owned the sawmill across the canal from Honeystreet Wharf. They produced timber products for the home market from both local hardwood and deal mainly imported from Scandinavia. Agricultural and garden products are still available at the sawmill. These pictures were taken ninety years apart and show a corner of the sawmill but of the wharf today only the tip of the chimney can be seen from this point.

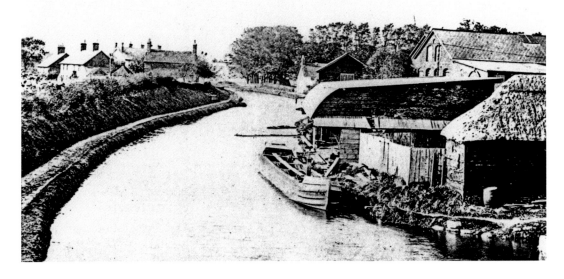

Honeystreet — Canal View

At Honeystreet Wharf new boats were launched sideways into the Canal down two composite timber beams, each carrying two rails. Between these rails slid a well-greased oak block, which took the weight of the boat. These timber beams can be seen floating across the canal from the boat-building shed. Today, some light industry lies behind the trees through which can be discerned the double-windowed gable end of one building that has spanned the years.

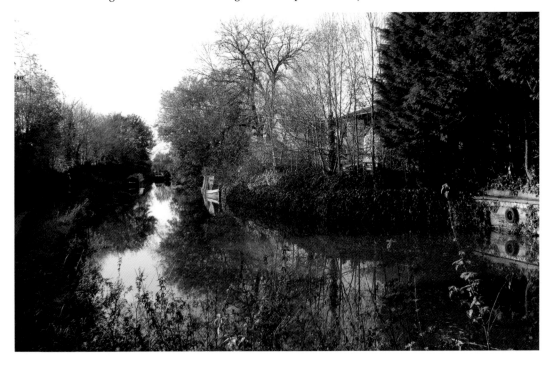

Honeystreet — Old Builders' Wharf
Immediately east of Honeystreet road-bridge was once a builders' wharf and adjoining house. Today, the wharf has been rebuilt and the business is one serving the needs of the leisure boater. Gibson's Boat Services provide diesel, water, gas, coal and pump-out facilities.

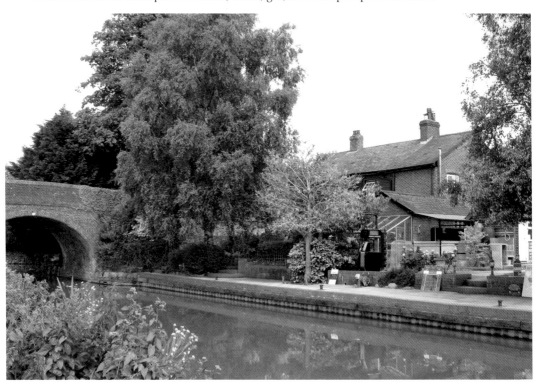

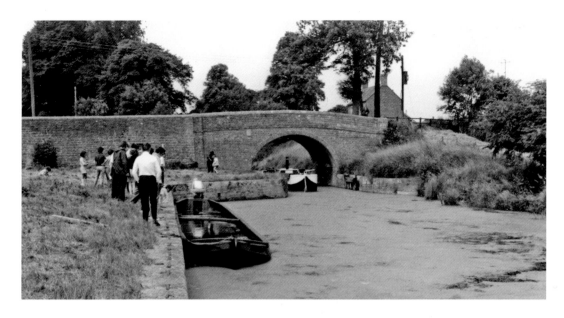

Pewsey Wharf

Four and a half miles east of Honeystreet is Pewsey Wharf, three quarters of a mile north of the village. Looking back towards Honeystreet the view is dominated by the bridge carrying the Pewsey to Marlborough road across the canal. The Canal Trust trip boat *Charlotte Dundas* is just emerging from the bridge hole *c.* 1975. Built from an old dredger pontoon and driven by paddles, this boat provided trips while the canal was still under restoration. The floating weed has gone leaving clear water for the many boats in this area.

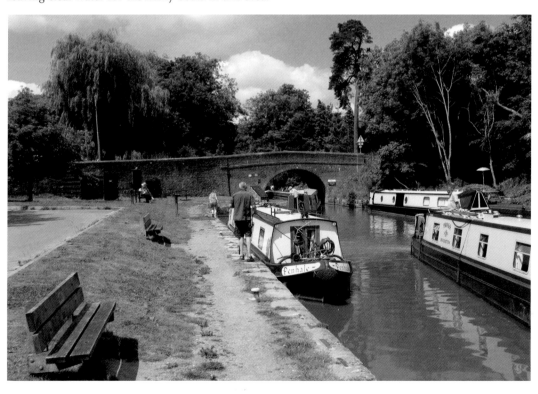

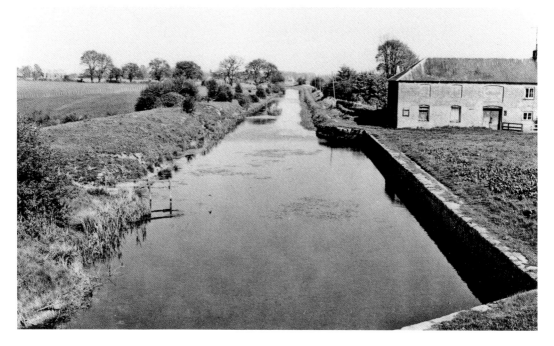

Pewsey Wharf

The warehouse still stands on Pewsey Wharf but even in the 1930s no sign of the crane remained. Once owned by the Canal Company, Pewsey Wharf is now owned by British Waterways. It was, and remains, a rural wharf that once traded in a wide range of goods. That trade has now gone, with moorings and visiting pleasure boats dominating the scene. The warehouse today houses a café and bar with on site public parking.

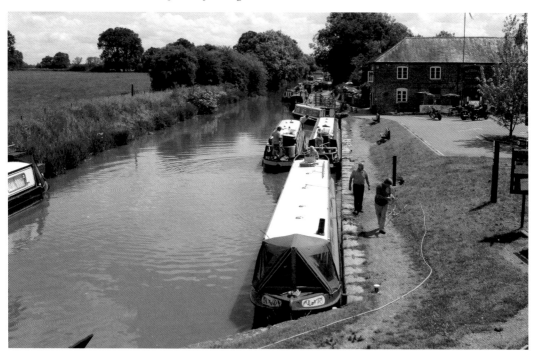

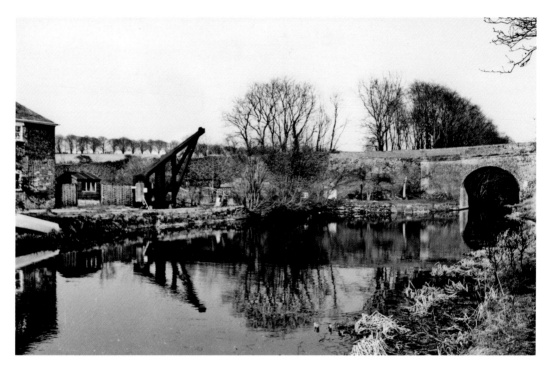

Burbage Wharf

From Wootton River four locks lead to the canal summit and Burbage Wharf. Looking east during restoration of the canal, a newly restored crane stands on the privately owned wharf adjacent to the road bridge. Today, that same crane is once more being restored by the Canal Trust, British Waterways, the Inland Waterways Association and Crown Estates. An information board can be seen alongside the towpath, giving a completion date of summer 2010.
Inset: wharf crane restoration notice

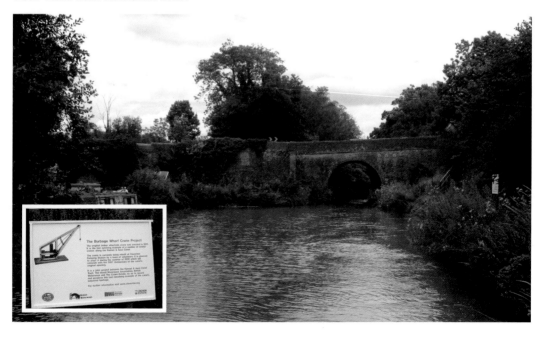

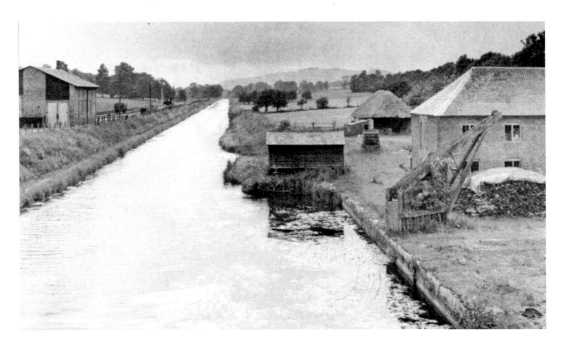

Burbage Wharf — Road, Rail and Water

Looking west from the road bridge at Burbage Wharf in 1938, railway sidings, the canal and road transport could be seen to come together. Timber from the Savernake Forest once left this wharf by canal when the site was owned by the Marquis of Ailsbury. The site was part of tenanted Wharf Farm, the tenant being the wharfinger. The crane was kept busy loading timber and grain. The barn is now a private residence and the crane is being rebuilt at Claverton Pump House. *Inset:* crane rebuild at Claverton. (Archive photograph from the collection of M. F. Yarwood)

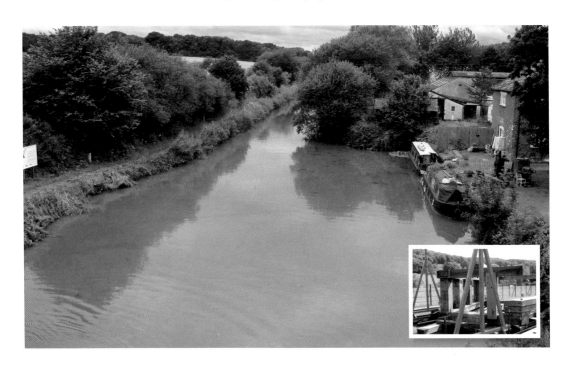

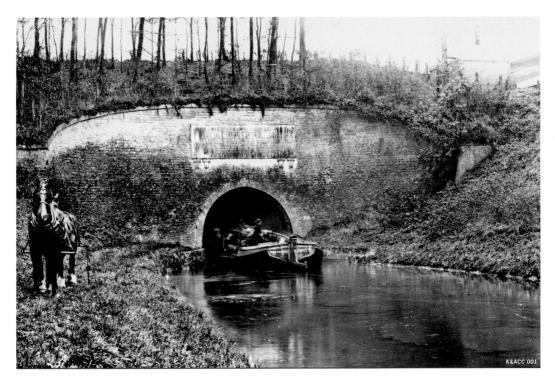

K&ACC 001

Bruce Tunnel

The barge *Unity* enters the eastern end of the 502-yard Bruce Tunnel loaded with timber, as the two horses are led away to take the path across the top to the western end in the early years of the twentieth century. The barge was propelled through the tunnel by crew hauling on a chain fixed to the wall. The author's boat prepares to make the same journey, though under diesel power.

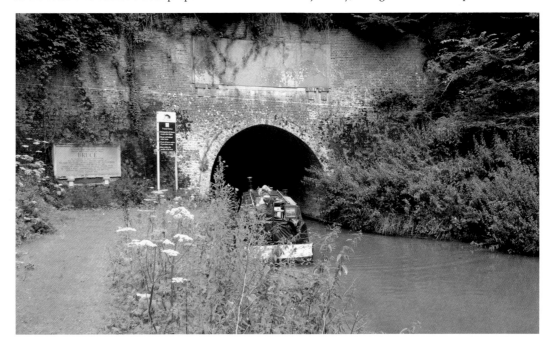

Crofton Flight of Locks

In the 1950s, the flight of six locks leading from the canal summit down to Crofton was a sorry sight with no water in the pounds. The pumping station and the chimney stack show clearly on the horizon. The rural scene now is more welcoming, with water in the canal and trees having slightly changed the view from this point as they hide the pumping station. (Archive photograph by F. Blampied)

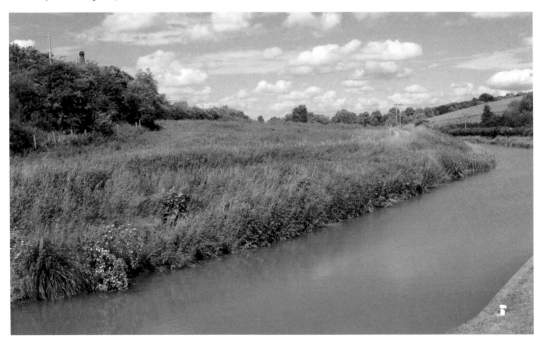

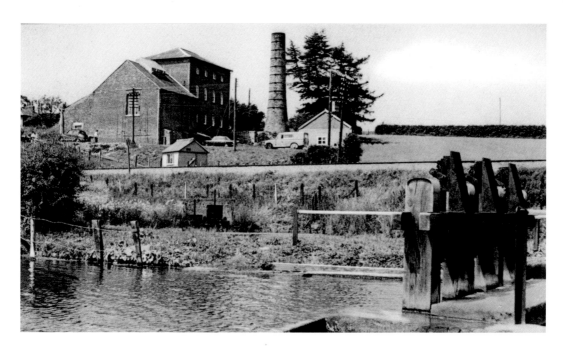

Crofton Pumping Station

In 1958, the boiler stack at Crofton pumping station was reduced in height for safety reasons. When the pump building and pumps were bought by the Canal Trust, an electric fan had to be fitted at the base of the chimney to compensate for the loss of draught. As a result of funds raised by the Trust's 'Buy a Brick' campaign and a major contribution from the Manifold Trust, the chimney can be seen to have been restored to full height making the fan redundant.

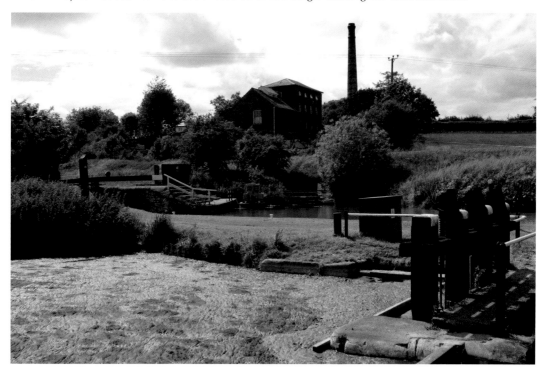

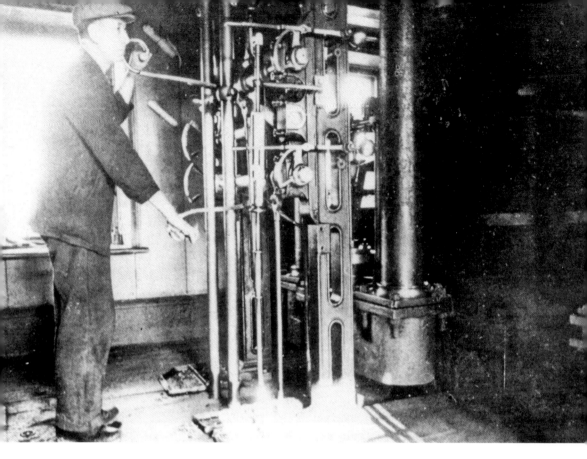

Crofton Steam Engines

Bill Giles occupies the driving platform of the steam pumps in the 1920s from where the steam valves had to be operated manually during starting and stopping of the steam engines. Following restoration, the scene remains unchanged and is a testament to the dedicated volunteers of the Canal Trust. This is 'industrial archaeology in a rural setting'. The two-beam engines date from 1812 and 1846 and are open to visitors during the summer and special steaming days. Notice the wood-soled clogs worn by Bill Giles and the contrast in clothing to the later operator.

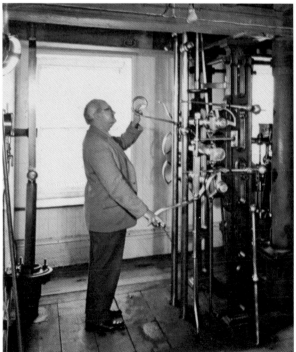

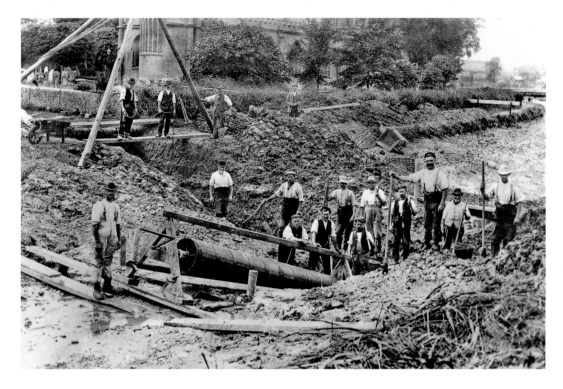

St Lawrence's Church, Culvert, Hungerford

Using ancient Egyptian technology originally revealed by Archimedes on his travels *c.* 220 BC, the Archimedes screw pump (or cochlea) is keeping water out of the culvert under repair below the drained canal. In the print of 1909 the Church of St Lawrence, Hungerford, is in the background as seen from the north bank of the canal. Trees mask the church today, and the position of the culvert is marked by steel piling retaining a part of the north bank.

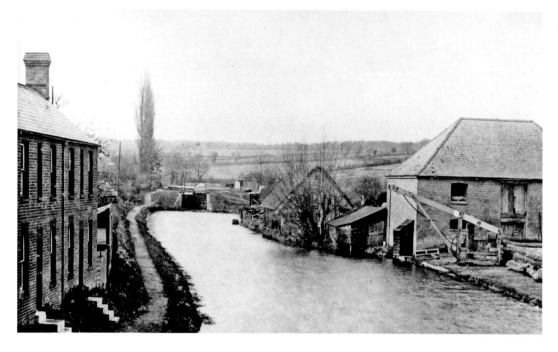

Hungerford Wharf and Lock

From the road bridge over the canal at the bottom of Hungerford main street, the lock gates are in the background and a glimpse of the wharf crane and the warehouse are on the right. The first cargo to Hungerford Wharf from Newbury by the new waterway, still under construction in 1798, composed dressed stone and Russian tallow. A brisk export trade in local hardwoods later developed. The wintry scene of 1900 is in contrast to a greener, brighter scene in 2009.

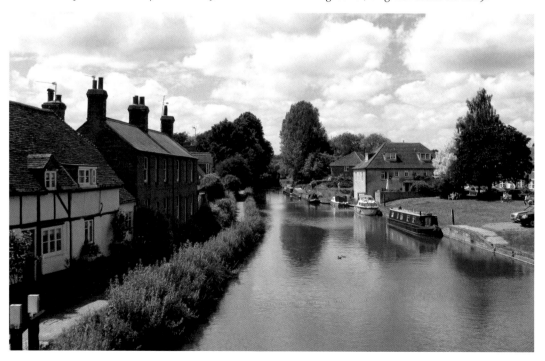

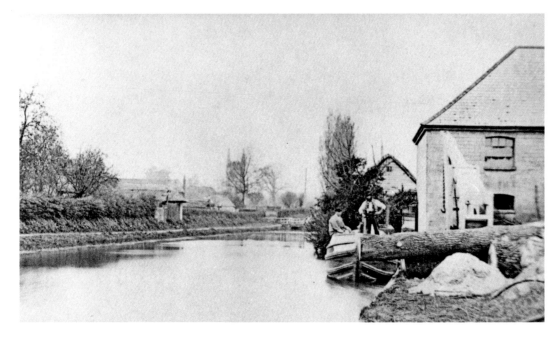

Hungerford Wharf and Crane

As the burly, bearded crewman on the narrow boat poses with his colleague a large baulk of timber awaits handling by the crane. The Church of St Lawrence could still be seen from the wharf looking westward *c.* 1900, but today, as is commonplace along this rural canal, the scene has been modified by the growth of trees and the presence of leisure craft.

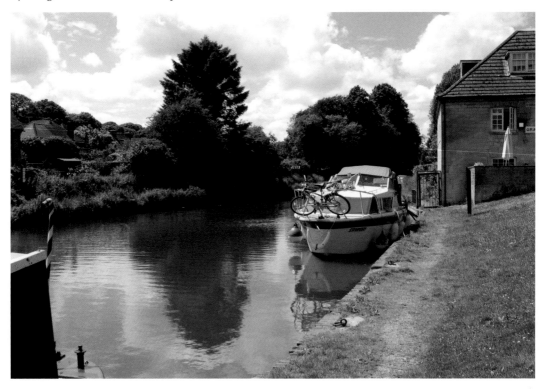

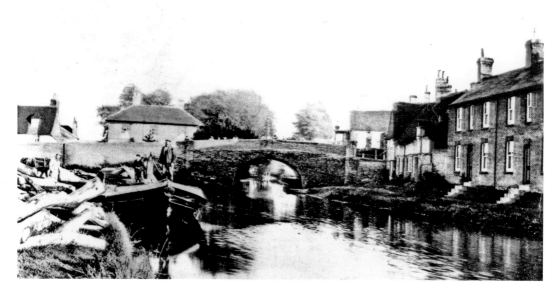

Hungerford Wharf and Road Bridge

Turning to look eastward towards the road bridge in 1908 there is further evidence of the timber trade at the wharf. The Canal Trust's trip boat, *Rose of Hungerford*, is berthed here when not taking guests on a leisurely cruise. The wharf area has been transformed into a pleasant open-grassed area where it is relaxing to sit and watch activity on the canal.

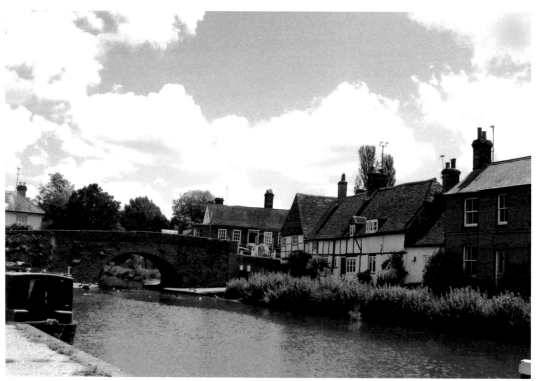

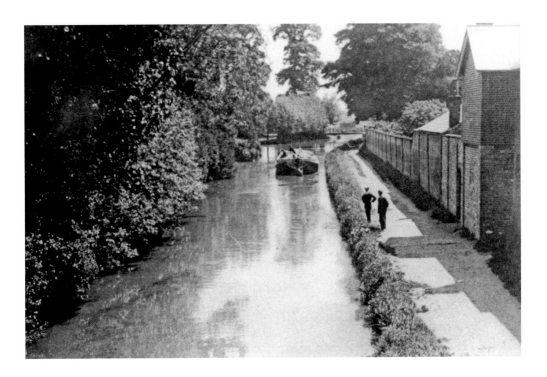

East From Hungerford

Looking eastward beyond the road bridge a Kennet barge is seen being horse drawn away from the town. The horse is lost in the shadow of a large tree as it approaches pumphouse swing bridge. The only change to the scene today is the replacement of the barge by a modern diesel-powered narrow boat.

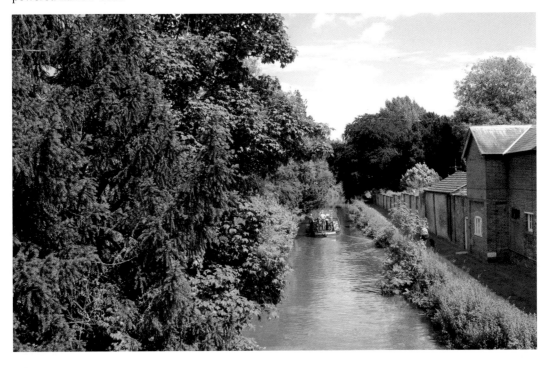

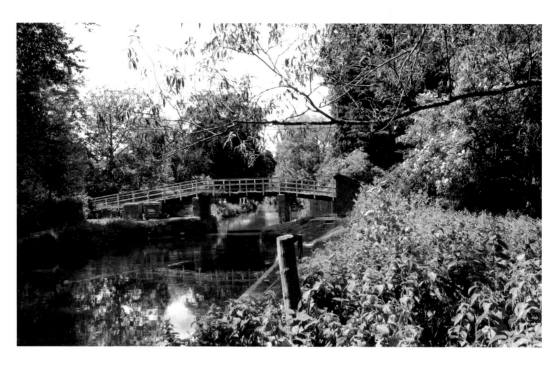

Hungerford — Pumphouse Swing Bridge

Pumphouse swing bridge is no more, having been replaced by a fixed pedestrian bridge. The area on the north bank was being cultivated *c.* 1910, but in 2009, during the 100-year interval between the photographs, nature has definitely taken over and the area is impenetrable.

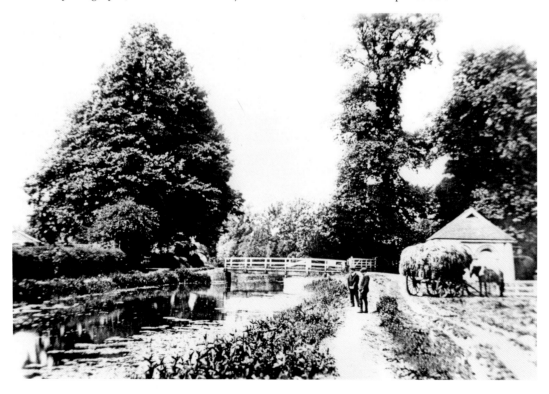

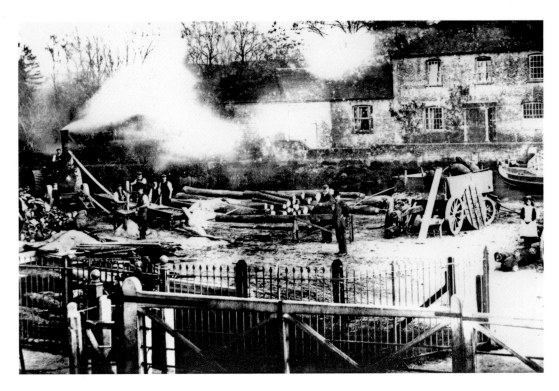

Kintbury Wharf

In 1898, coal was the main power source as it was used to turn water into steam under pressure to do work — just as this traction engine is doing on Kintbury Wharf. With a single belt drive it appears to be driving a circular saw bench and a planer sharpening the end of fence posts. A little girl, resplendent in a white apron, has sneaked in on this picture. Today, the area provides extra parking for the Dundas Arms across the canal. (From the collection of Sue Hopson)

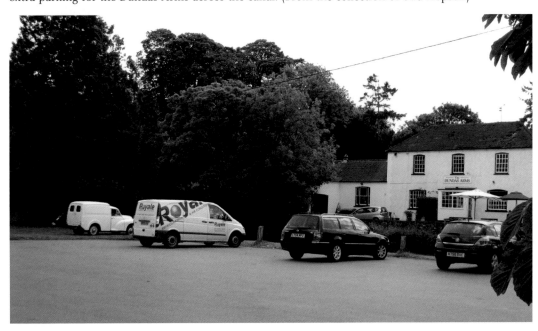

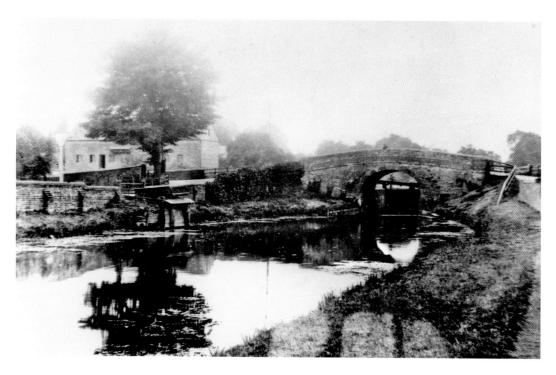

Kintbury Wharf and Road Bridge
Kintbury Mill, the road bridge and the bottom lock gates can all be seen in this early twentieth-century photograph taken from what was Kintbury Wharf. The stone bridge has been replaced by a wider modern — though less appealing — structure.

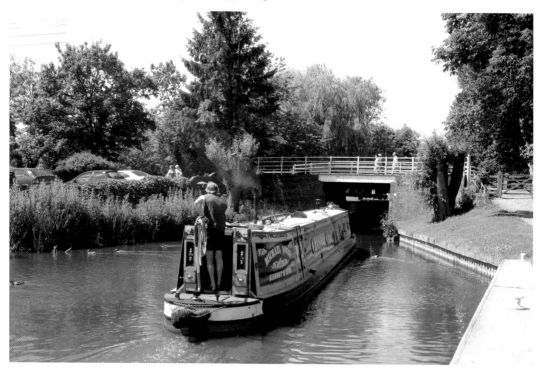

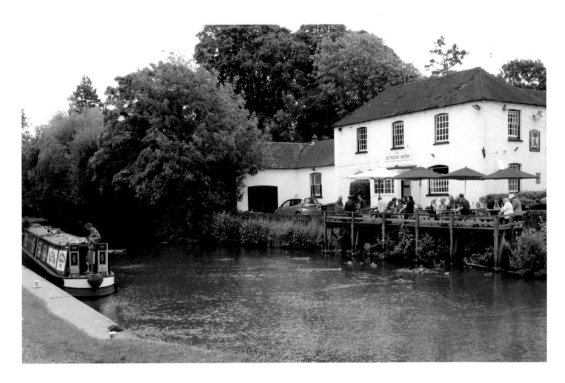

Kintbury — Loading Grain

A narrow boat departs, under the gaze of onlookers at the Dundas Arms, where once was Kintbury Wharf. Boat traffic was once trading here, such as the wide boat *Betty*, owned by H. Dolton and Son, Newbury, seen here in 1908 loading sacks of grain. The wharf once received iron ore and coke from south Wales, and malt and corn. Chalk whiting from Irish Hill left here for the Bristol paint industry and timber for Reading. (From the collection of G. Collier)

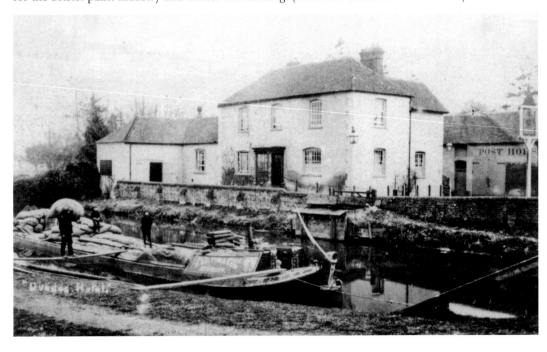

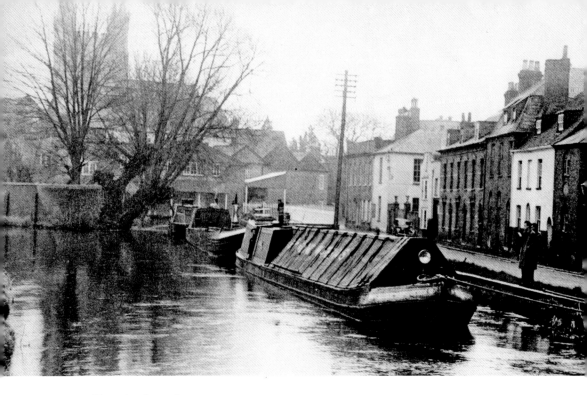

West Mills Wharf Newbury

John Knill's boat *Columba* (later *Sir John Knill*) is seen moored at West Mills Wharf, Newbury, in February 1950. It had just completed a journey from Middlewich in Cheshire with sacks of salt for Newbury Laundry. The iron work spanning the entrance to what was once Adey's coal yard remains. The wharf handled not only corn for the mill but a wide variety of goods.

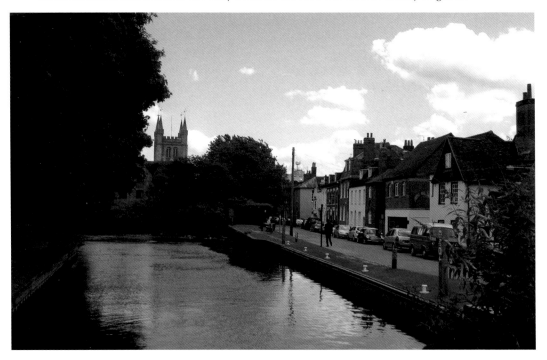

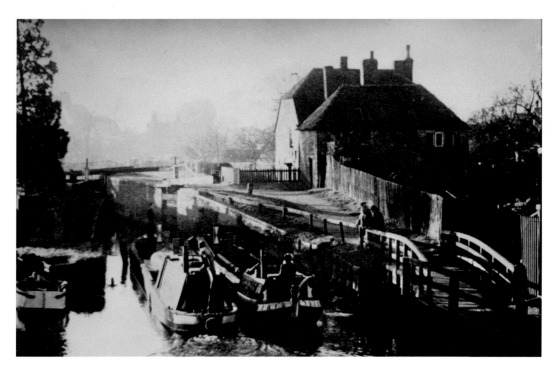

Newbury Lock

A breasted-up narrow boat and butty approach Newbury lock heading west *c*. 1949. The lock cottage on the right no longer exists; built with the lock in 1796, it burned down in the 1980s. Otherwise the scene has changed little in sixty years, with the river Kennet emerging under the footbridge on the right before flowing under Town Bridge.

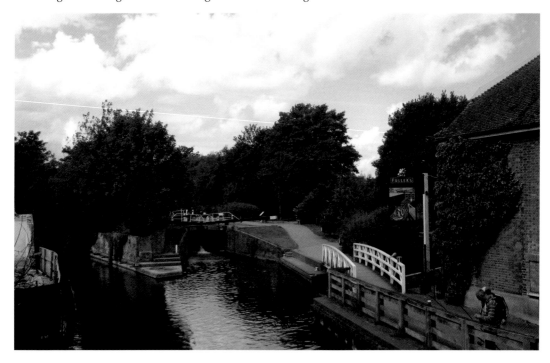

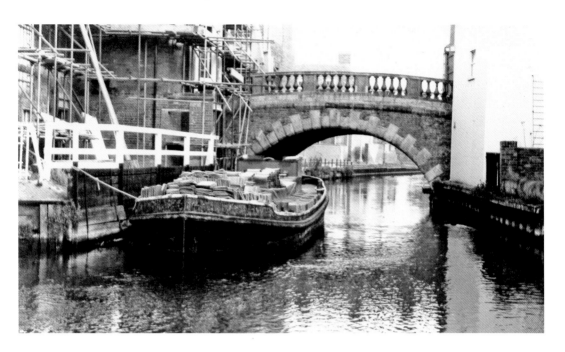

Newbury Town Bridge

The River Kennet emerges below the lock at Newbury before flowing under Town Bridge. In the earlier photograph a moored barge laden with roof tiles is moored in a position making navigation hazardous, if not impossible, on the river above the bridge. Approximately sixty years separate the two photographs.

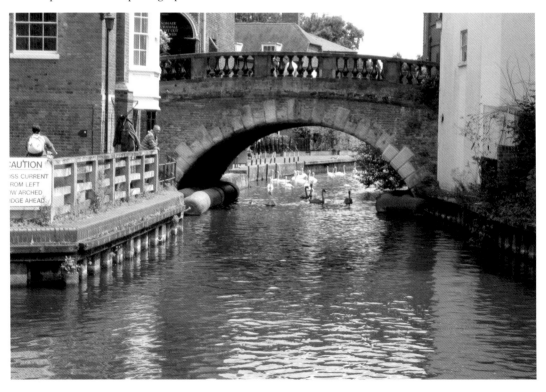

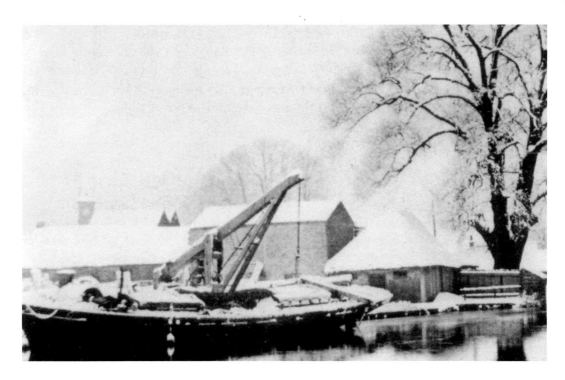

Newbury Wharf

In a hard winter *c.* 1919 the boat *Mate* lies alongside Newbury Wharf opposite Victoria Park, obscuring a view of the timber wharf. Two basins once existed here but have now been filled in. The entrance to these basins would have been under today's bypass bridge and they now lie partly below the library. The 'Stone Building', once part of a larger structure, still survives, and a coal yard crane has replaced the Kennet crane, a reminder that Newbury was once one of the largest inland ports in the country.

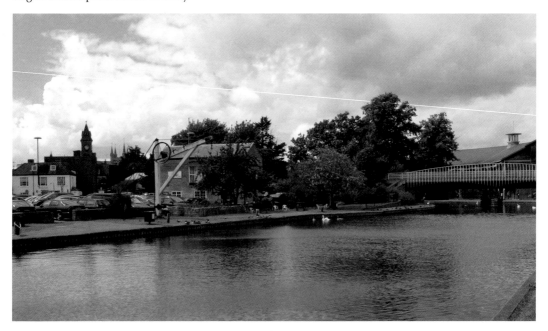

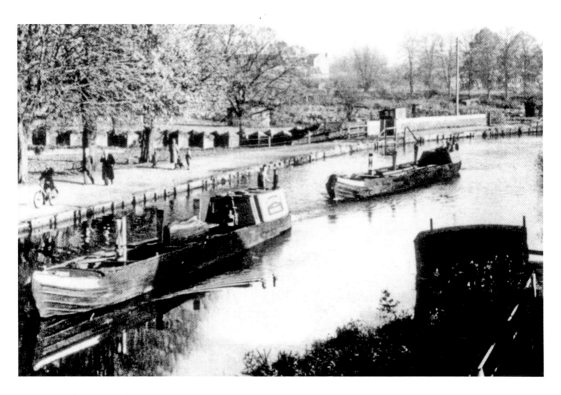

Newbury — Victoria Park

John Gould's pair of narrow boats, *Colin* and *Iris*, head up river at Victoria Park, Newbury, in the winter of 1949. The concrete 'dragon's teeth', positioned in 1940 to prevent Herr Hitler's tank crews enjoying the delights of Victoria Park, still lurk in the background. Both photographs are taken from the position of a past corn wharf. The dismal scene of 1949 gives way to a more active scene during the Newbury Water Festival in 2009. (Festival photograph by Patrick King)

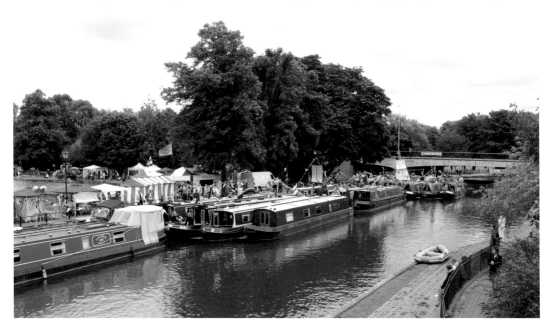

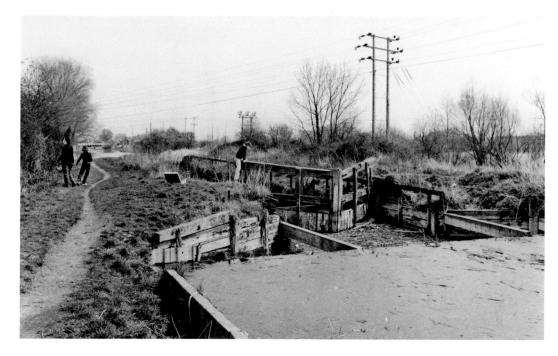

Thatcham — Monkey Marsh Lock and Road Bridge

All the locks on the Kennet navigation were once turf sided — that is, shuttered to just above the lower water level and then sloped off towards the top. Prior to restoration of the navigation during 1968 to 1990 many locks had been unfit for use. At Monkey Marsh lock outside Thatcham a temporary dam kept the weight of water off the lower gates. Looking east, Thatcham swing bridge can be seen in the background but today its replacement is a modern fixed-structure.

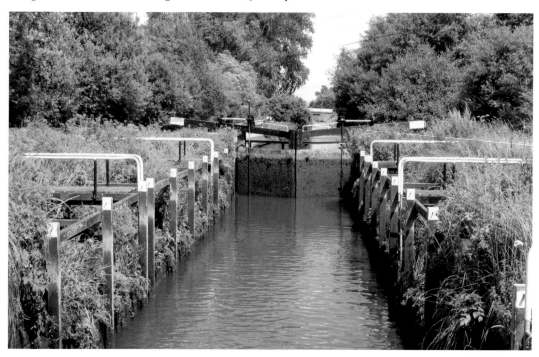

Thatcham — Monkey Marsh Lock

A lady in cape and bonnet picks flowers while a Great Western Railway work boat waits to ascend Monkey Marsh lock *c.* 1905. Today, boats can moor here while crews work the lock in a scene recreated with the help of an obliging passer by. Between this point and Thatcham Bridge boats can moor while crews visit Thatcham or the adjoining railway station. (Archive photograph from the collection of R. White)

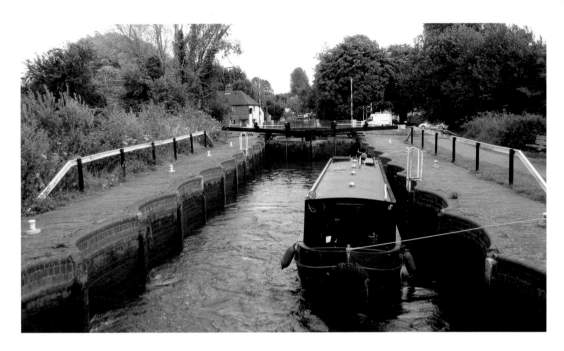

Aldermaston Lock

At Aldermaston the newly restored lock bears little resemblance to its condition during the restoration years. The scalloped brickwork of what was once a turfsided lock has been retained, one of only two locks on the navigation having this feature. Both photographs reveal the 'new' bascule bridge in the background.

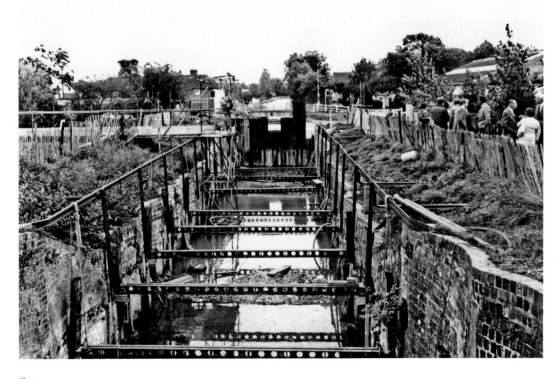

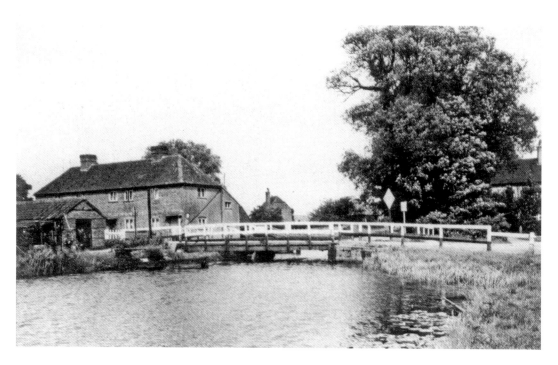

Aldermaston Swing Bridge

A modern bascule bridge replaced the old wooden swing bridge at Aldermaston in 1984. This is a busy road over the canal and difficulty in moving the swing bridge caused many delays. After reinforcement with steel girders in 1963 the old bridge was rendered immovable. The beginnings of a short arm of the canal to the left can just be seen. This was an interchange arm with the railway constructed in the 1850s. (Archive photograph from the collection of Michael E. Ware)

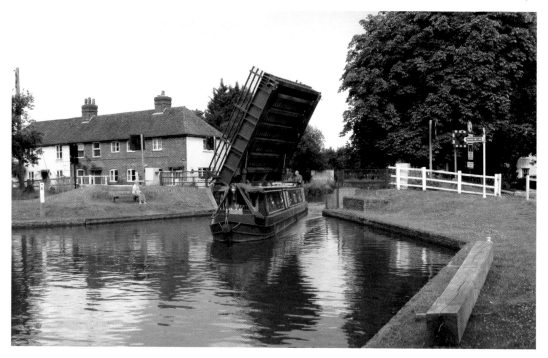

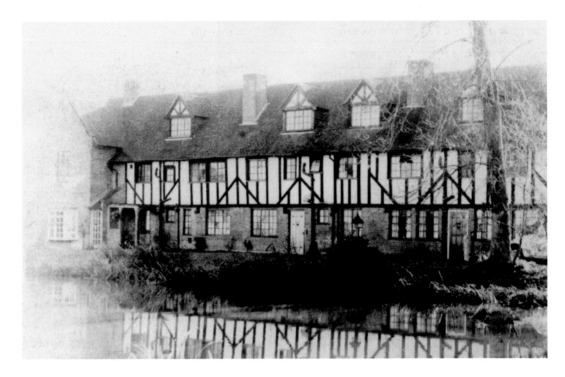

Aldermaston Malthouse

Nearly sixty years separate these two photographs of the old malthouse just east of the bascule bridge at Aldermaston and beside the site of Aldermaston Wharf. The photographs are taken from Lower Wharf on the towpath side of the canal. Although the malthouse has not changed in sixty years, Lower Wharf now sees much more boat activity.

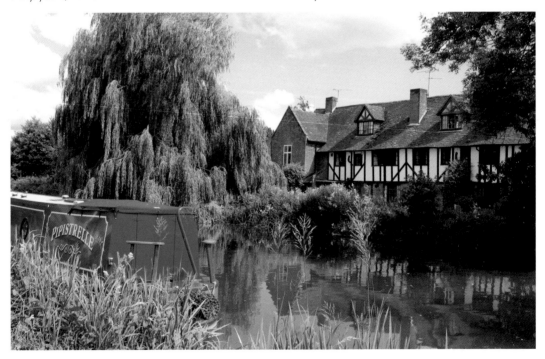

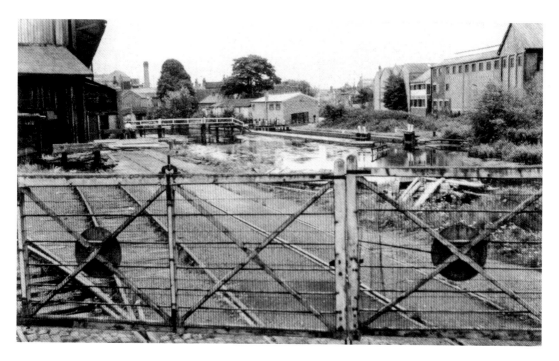

Bear Wharf — Reading

Looking across the River Kennet towards County Lock in 1961, Bear Wharf was still supplied by a rail siding. Soon after the navigation opened in 1723 Bear Wharf became one of the most important wharves in Reading. The coal basin was filled in by the late nineteenth century and today even the sidings have gone, to be replaced by housing.

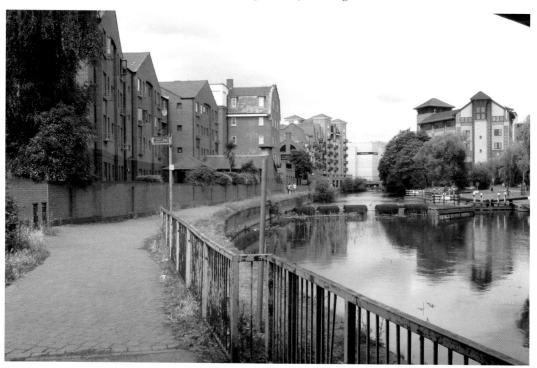

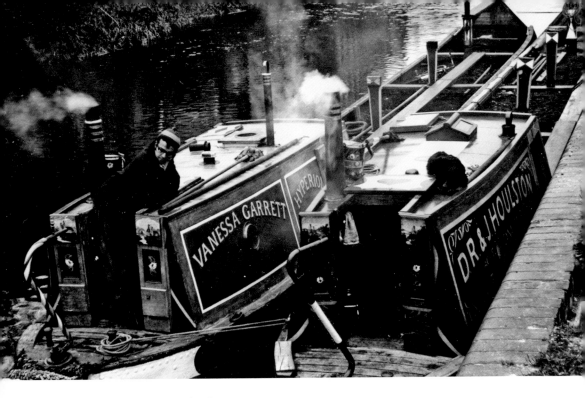

Reading — Boats at Bear Wharf
Still at Bear Wharf but stepping through the inner distribution road bridge to look upriver, we find the position where c. 1965 two boats were tied up while the crews took a break; the smoke emanating from the chimneys indicates a cold day that necessitated warming fires. They were on their way to a boat rally and the later scene shows that boats still moor here today.

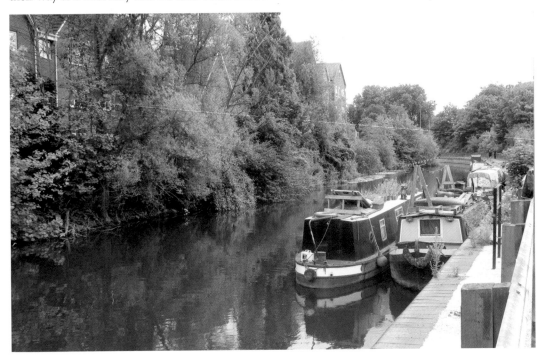

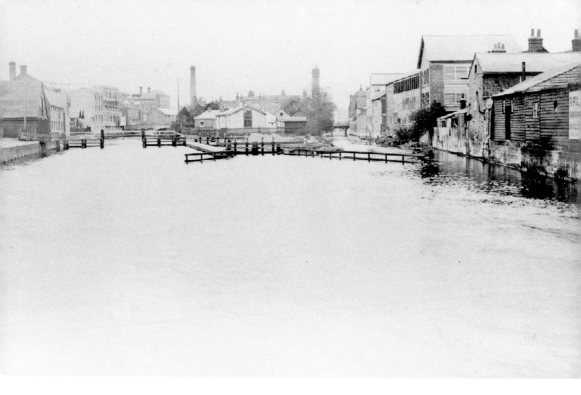

County Lock — Reading

The area surrounding County Lock, Reading, has changed dramatically since 1898. Gone are the warehouses beside St Giles' Mill Stream on the right, replaced by a row of trees, above which is the inner distribution road. The top gates of the lock can be seen between St Giles' Mill Stream and the weir on the left. Buildings to the right and left of the River Kennet weir have been replaced by offices and housing. (Archive photograph from the collection of Reading Central Library)

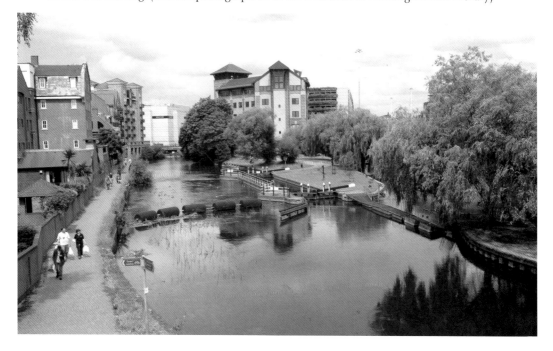

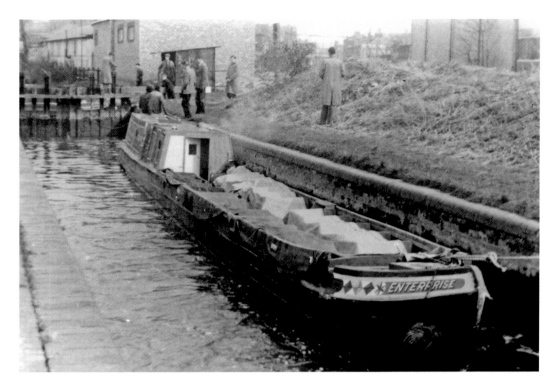

Enterprise in County Lock — Reading

The narrow boat *Enterprise* waits for County Lock to fill as it heads upriver *c.* 1958. The covered seats in the hold reveal that this was a trip boat. It was owned by Ran Meinertzhagen who ran pleasure trips between Reading and Burghfield. The lock has changed little but the surroundings are now more open and are greener.

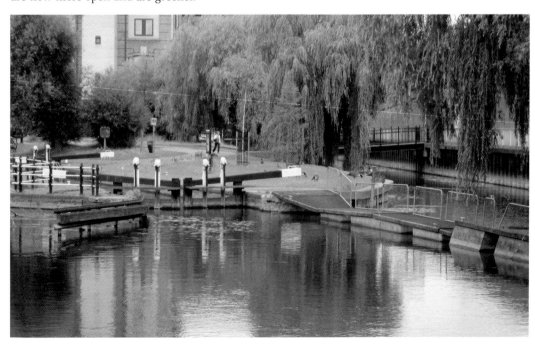

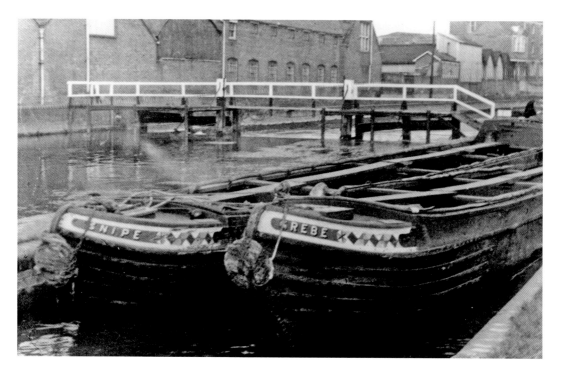

Snipe **and** *Grebe* **at County Lock — Reading**

The working narrow boats *Snipe* and *Grebe*, owned by Willow Wren Carrying Co., prepare to leave County Lock in 1958 having journeyed to Reading to support Ran Meinertzhagen's inaugural trip boat journey to Burghfield. Today, by the bottom gates of the lock are traffic lights; these control the passage of boats navigating a narrow, twisting section of the river through Reading to High Bridge.

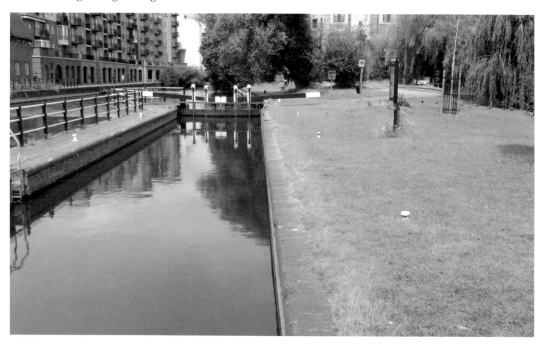

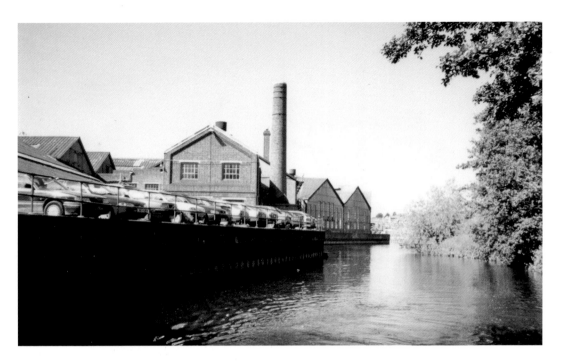

Brewery Gut — Reading

Brewery Gut, apart from being a nasty gastric disorder, is the name given to a twisting stretch of the River Kennet through Reading. In 1885, Simmons Brewery bought the towpath from the Great Western Railway Co. and extended their premises, narrowing the navigation. The industries that once bordered the river have today given way to the Oracle shopping centre.

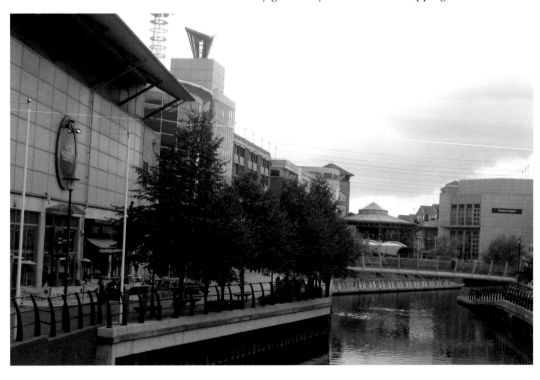

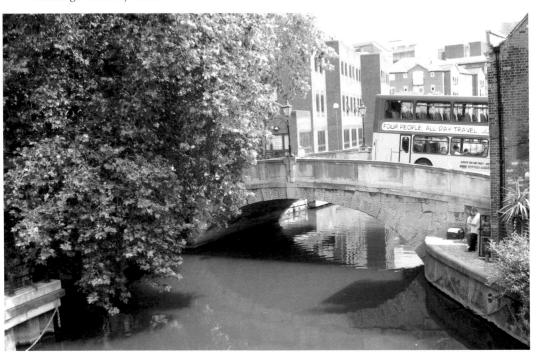

High Bridge — Reading

High Bridge makes a sharp bend in the river completely blind for helmsmen, as the 1965 photograph shows. It is one of the reasons for the controlling traffic lights. This was the limit of navigation until 1723, and from this point downstream the navigation remains under the jurisdiction of the relevant Thames navigation authority. In the thirty-five years separating these photographs the lamps on this bridge may not have changed but the buildings certainly have.

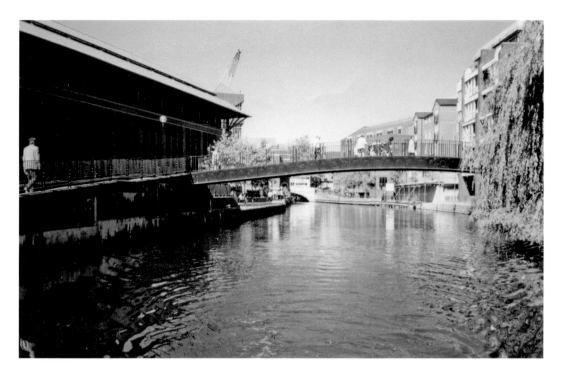

High Bridge Wharf — Reading

Looking upriver in 1997 with High Bridge in the far background, remnants of Reading's commercial canalside past remain. Just twelve years later it has gone. The traffic lights controlling upstream traffic through Brewery Gut are on the right just below High Bridge and are being approached by the boat in the later photograph. This was also the site of Highbridge Wharf which did not cease activity until 1945.

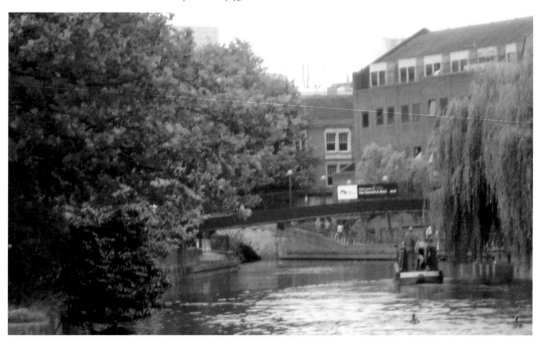

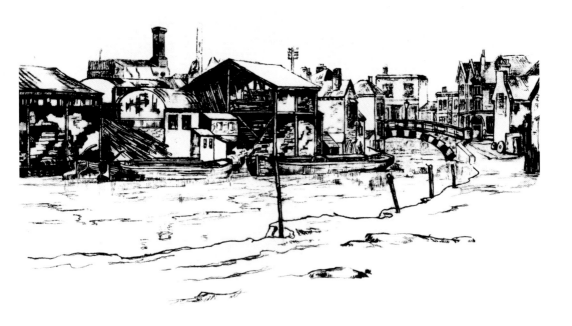

Starlane Wharf — Reading

A drawing of Starlane Wharf in 1921 by local artist N. H. J. Clarke places its position quite clearly downriver from High Bridge. The artist was positioned at Crane Wharf, just downriver from Highbridge Wharf. A multi-storey car park marks the Starlane site today. This area below Highbridge was once at the heart of Reading's trading and industrial past.

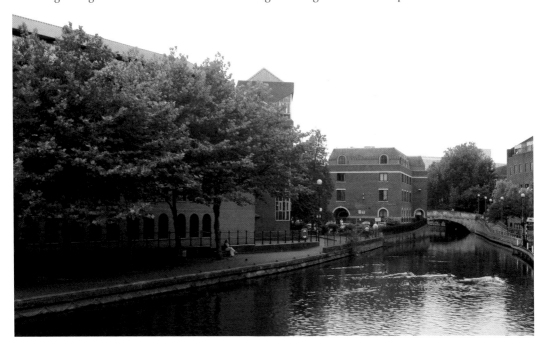

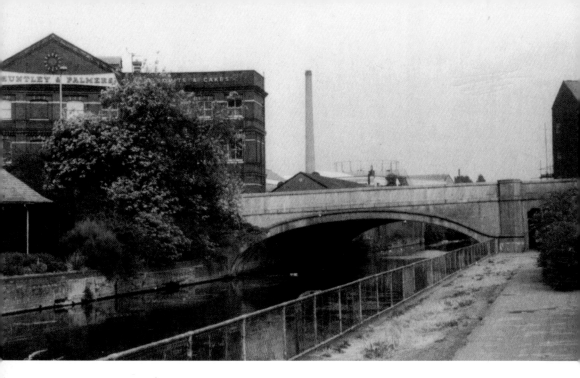

Kings Road Bridge — Reading

Forty-five years lie between the two photographs at Kings Road Bridge at Reading. Huntley and Palmers biscuit factory building is still there though no longer producing biscuits. The factory used waterways in preference to roads as the smoother transportation minimised the quantity of broken biscuits. This was an important industry in the city and the wharves and jetties of the biscuit factory were always busy. *Inset:* Huntley & Palmer logo

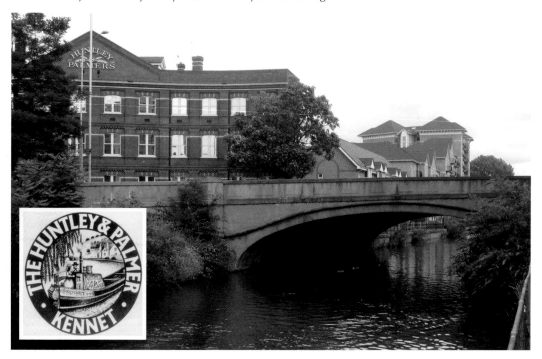

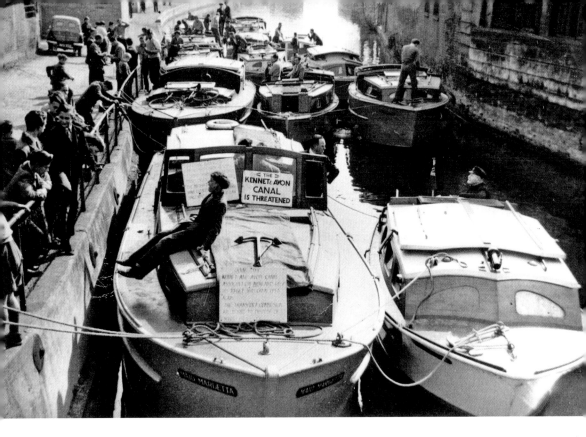

Maid Line Cruiser Rally — Reading

In April 1956, a Maid Line Cruiser rally was held on the river Kennet upstream from Blakes Lock, the last lock before the River Thames. The owner of Maid Line Cruisers, Lionel Munk, is seated on Maid Margetta. The placard on this boat emphasises that the canal (navigation) at this time remained under threat of closure, although Parliament in 1956 refused to close it. Today, following thirty years of restoration, its future is assured. (Archive photograph by F. Blampied)

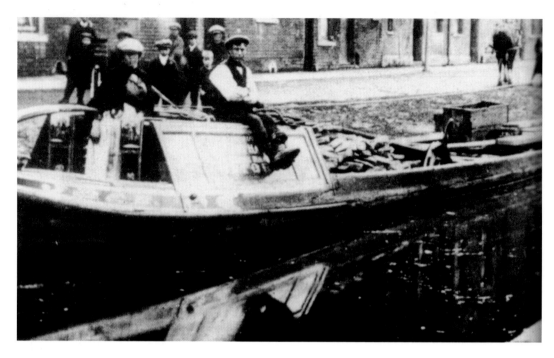

Kennet Side — Reading

In 1923, Jack James and his wife posed for a photograph above Blake's Lock at Kennet Side, Reading, aboard their narrow boat *Jack*, while the horse made it clear it did not wish to be included — unlike the gaggle of small boys in the background. The scene has changed little today, but the moorings for boats waiting to enter Blakes Lock are new.

Kennet Side from Blakes Lock — Reading

The Reliant Robin car probably dates the older photograph as *c.* 1965. It is a general scene looking upriver from the top gates of the last lock before the river Kennet inauspiciously enters the River Thames. The towpath continues for the few hundred yards to Kennet Mouth where it joins the Thames Path. Having walked the Reading waterfront from County Lock to Kennet Mouth, the red umbrellas mark the Fisherman's Cottage pub for welcome refreshment.

95

Devizes Wharf
museum & shop
Tel: 01380 729489

The Kennet and Avon Canal Trust

The Kennet and Avon Canal Trust developed from organisations formed to fight the closure of the canal in the 1950s. Supporters and volunteers successfully fought the British Transport Commission and lobbied Parliament to prevent closure and bring about restoration. The trust today works with British Waterways and the riparian authorities to bring about its objectives and to work for continued improvement of the Waterway for public enjoyment. The canal today is enjoyed by boaters, anglers, walkers, cyclists, naturalists and anyone interested in archaeology or heritage-related subjects. The aims of the trust are (a) to protect the canal from neglect or abuse, (b) to enhance the canal and (c) to promote the amenity value of the canal. To find out more about the trust or membership ring 01380 721279 or visit www.katrust.org.uk.

Acknowledgements

The author wishes to thank the Kennet and Avon Canal Trust for allowing use of images from its vast archive. Without the trust's help this book would not have been possible. Acknowledgement is granted to all those who have generously provided originals or copies of photographs for use by the trust; many were given anonymously, but credit has been given in the text where donors are known. Thanks also to those volunteers at the trust archive who assisted in copying digitised images and provided necessary administrative advice — Elaine Kirby, Jeremy Haywood, Sarah Gould and Terry Kemp. The assistance patiently given by my wife, Helen, in taking photographs and deciphering and reading my scribbled text is gratefully acknowledged. I apologise to anyone who has been left out unknowingly and any such errors brought to the author's attention will be corrected in subsequent issues. Andy King, the curator of the Bristol Industrial and Maritime Museum, gave invaluable help in identifying sites at Bristol's Floating Harbour. Finally, the author wishes to thank Amberley Publishing for its generous acknowledgement of the co-operation of the K&A Trust.